MATISSE

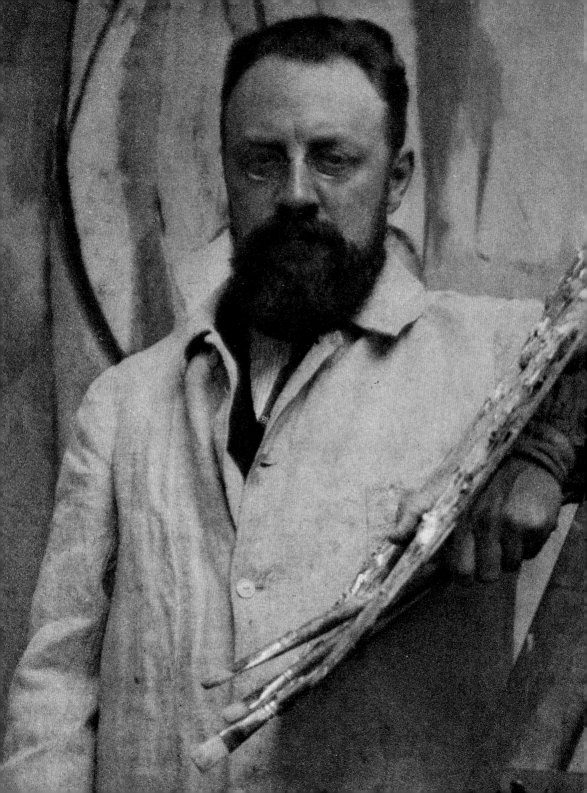

MASTERS OF ART

MATISSE

Eckhard Hollmann

PRESTEL

Munich · London · New York

Front Cover: Henri Matisse, Large Reclining Nude, 1935

© Prestel Verlag, Munich · London · New York, 2022,
A member of Penguin Random House Verlagsgruppe GmbH
Neumarkter Straße 28 · 81673 Munich

© for the reproduced works by Henri Matisse by Succession
H. Matisse / VG Bild-Kunst, Bonn 2021

In respect to links in the book, the publisher expressly notes that no illegal content was discernible on the linked sites at the time the links were created. The Publisher has no influence at all over the current and future design, content or authorship of the linked sites. For this reason Penguin Random House Verlagsgruppe expressly disassociates itself from all content on linked sites that has been altered since the link was created and assumes no liability for such content.

A CIP catalogue record for this book is available
from the British Library.

Editorial direction: Stella Christiansen
Translation: Jane Michael
Copyediting: Vanessa Magson-Mann, So to Speak
Production management: Andrea Cobré
Design: Florian Frohnholzer, Sofarobotnik
Typesetting: ew print & medien service gmbh
Separations: Reproline mediateam
Printing and binding: Litotipografia Alcione, Lavis
Typeface: Cera Pro
Paper: 150g Profisilk

MIX
Paper from
responsible sources
FSC® C021956

Penguin Random House Verlagsgruppe FSC® N001967

Printed in Italy

ISBN 978-3-7913-8739-0

www.prestel.com

CONTENTS

INTRODUCTION

When in 1891, the 22-year-old Henri Matisse abandoned his preparations to study law and enrolled at the Académie Julian in Paris to become an artist, the die was cast. Not, however, to lead a miserable artist's life of drink and poverty, as his parents feared, but rather to embark on a remarkable career which would make him the most important artist of the first half of the twentieth century in France, alongside Pablo Picasso and Georges Braque.

He first attracted public attention as a member of a group of young, unconventional artists whose exhibition caused a stir during the Salon d'Automne of 1905 and earned for the ten participating painters the label *Les Fauves* (The Wild Ones). They had all distanced themselves from the hidebound traditions of academic painting and referred instead to Vincent van Gogh, Paul Gauguin, Paul Cézanne and the Neo-Impressionists. Despite all their differences, they shared two things: the use of pure colours and at the same time a simplified, clearly defined artistic language. Thus, the Fauves established the French variant of Expressionism, which achieved a similar importance in French art as did *Die Brücke* and *Der Blaue Reiter* in Germany. Matisse's works achieved increasing international acclaim. Rich collectors, especially the Russian businessman Sergei Ivanovich Shushukin, helped the artist to gain prosperity by purchasing his paintings on a large scale and by enabling him to follow his trajectory as an artist.

Matisse greatly admired the poet Charles Baudelaire and liked to quote his poem *Invitation to a Journey* from *The Flowers of Evil*: "There, all is order and loveliness / Luxury, calm and voluptuousness." Under the influence of the Neo-Impressionist Paul Signac, Matisse painted a programmatic work on this subject in 1904, which he also called *Luxury, Calm and Voluptuousness*.

Art was more important to Matisse than anything else in his life. For him it meant hard work, tenacity, alertness and infinite patience. He was peerless within his field of contemporary art, uniting the qualities of a bourgeois citizen, a bon-vivant and a thoroughbred artist!

His family was close-knit—Amélie, his wife of many years, his daughter Marguerite from a pre-marital relationship with his model Caroline Joblaud, and his two sons Jean Gérard and Pierre, and a relaxed and loving atmosphere prevailed among them. The fact that Amélie left her husband after forty years of marriage, however, was indeed also because he established close relationships with his models, claiming that otherwise he would not be able to paint them. These close and intimate relationships

could sometimes include sexual undertones, although this was not always the case. They were, however, the essential precondition for the creation of his art. It may well have devastated him that the balance between such affairs and his family life collapsed after four decades, with Amélie leaving him, but it failed to make him change his ways. Moreover, he had found in Lydia Delectorskaya a young woman who would simultaneously become his model, loyal friend, assistant and carer in old age—a truly incredible story.

Matisse did not maintain particularly close connections with other artists, but throughout his life he stayed in contact with many colleagues whose work interested him. He met Albert Marquet in 1892 and travelled to Morocco with him in 1911 and made the acquaintance of Henri Manguin, Georges Rouault and Simon Bussy at the Académie Julian. He admired Auguste Renoir and met the Old Master on several occasions. He sought contact with Auguste Rodin, a visit which, however, he found "disappointing", and he exchanged letters regularly with Pierre Bonnard for many years. The relationship between Henri Matisse and Pablo Picasso was truly remarkable. Françoise Gilot, herself an artist and the long-standing companion of the world-famous Spanish artist, wrote a comprehensive and well-informed book about their multi-faceted relationship, which was marked both by empathy and rivalry. The two men regarded themselves as the leading artists of French Modernism.

At the beginning of his artistic career, Matisse adopted a realistic painting style using dark colours, influenced by his teacher, Gustave Moreau, and by his study of the Old Masters. That, however, was not enough for him. His study of the Impressionists led him into his Neo-Impressionist phase, in which he created important pictures like *Luxury, Calm and Voluptuousness* in 1904. He eventually developed a two-dimensional style based on that of Cézanne and Gauguin, working with only marginally modulated, bold colours, then progressing to clearly structured, rhythmic compositions, like *Dance II* (pages 50/1) and *Music* (pages 52/3). In these pictures he succeeded in harmonising simplified forms and brilliant colours with decorative elements. They led on seamlessly to the magnificent cut-outs of his final creative period. Matisse's oeuvre resonated throughout the whole of Europe with reactions extending from boundless enthusiasm to incomprehension and rejection. Today he is rightly regarded as one of the most important forerunners of Classical Modernism.

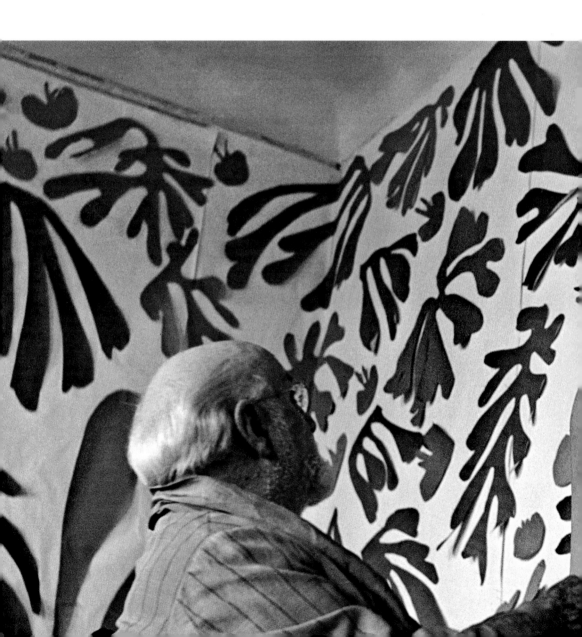

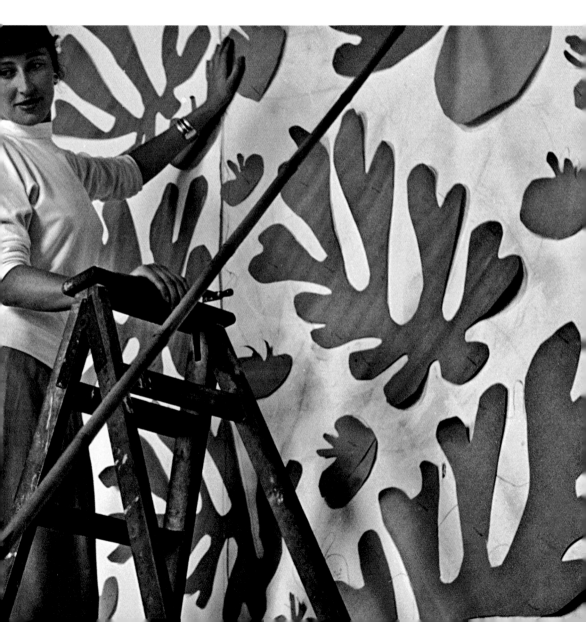

LIFE

A sheltered bourgeois life

Henri Matisse was born on New Year's Day 1869 while the family was on a visit to his grandparents' house in Le Cateau-Cambrésis, a small town in northern France. He was christened Henri Émile Benoît. Matisse's mother, Anna Gérard, worked in a hat shop in Paris; his father, Émile Hippolyte Henri Matisse, was a "commis", a buyer in a Parisian fashion store at the time. His parents were aged 24 and 28 when they married. Émile later ran a grain merchant's business in Bohain-en-Vermandois and achieved considerable prosperity. It was there that Henri Matisse grew up, "surrounded by a watchful, protective network of aunts and uncles and cousins".

This sheltered period came to an abrupt end in 1882. Henri, now aged 13, was sent to the Lycée Henri Martin in Saint-Quentin, a martial educational establishment by present-day standards: "a strict, barracks-like complex, a sort of military monastery, ruled by the beating of a drum in the school playground, where the pupils exercised. They all wore the paramilitary clothing that was standard at state boarding schools in France: uniform kepis and dark high-necked uniform tunics with brass buttons." The educational aim was quite clear: the boys were to be turned into loyal, reliable and conforming citizens.

In the case of Matisse, these efforts failed utterly. After he finished school, at the age of 17, he went to Paris to work in a lawyer's office and to obtain the "Certificat de capacité en droit" at the university, a diploma introduced by Napoleon in 1804 to strengthen the bureaucracy of the governmental departments. In this he succeeded effortlessly, but also without even the slightest hint of enthusiasm. After working as a lawyer's assistant in Saint-Quentin for a year, his legal career was over, and he returned to Paris again—but this time with the aim of becoming an artist.

Paris: the difficult path to art (1890–1895)

Nowadays we would know nothing at all about the artist Rodolphe Julian, born in 1839, if he had not founded the Académie Julian in 1868, one of the many private art schools in Paris. As in most establishments of this kind, the focus was on the art of past centuries—the Renaissance and Baroque eras—as well as on contemporary Salon painting. The term refers to the Salon de Paris, a major exhibition of contemporary art which had been held regularly in the Louvre since 1667. The Salon was regarded as an "exhibition" of courtly art, and later as a stage for the tradition-conscious academicism in France. All art students aspired to show their works there.

The artistic training may have been conventional, but the teaching stood out from that of most of the private schools in Paris. From the beginning, the Académie Julian accepted female students and was also open to foreigners without subjecting them beforehand to a rigorous language test, as was customary at the state art academy.

XXXIII

Alvin Langdon Coburn, Matisse in the studio of Issy-les-Moulineaux, 1913

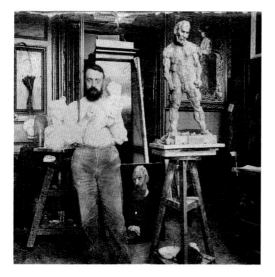

Matisse with the first version of the sculpture
The Serf, 1900

An international student community of both sexes populated the studios and teaching rooms when Henri Matisse entered the Académie Julian in 1891, having failed to pass the entrance examination for the state art academy, the École des Beaux-Arts. He enjoyed the atmosphere of the school, but he felt no connection whatsoever with the pictures of his teacher Adolphe-William Bouguereau. Neither the sleek, naturalistic painting style nor the historical and religious subjects of his works interested him.

In 1892, Matisse left the private academy and became a student in the studio of the Symbolist painter Gustave Moreau. At the suggestion of the latter, Matisse copied the works of the Old Masters in the Louvre and made a study of *plein-air* painting, but he failed the entrance examination for the *École des Beaux-Arts* again in 1892. Still he refused to give up, because he was determined to achieve the goal he had set himself. He now started to attend evening courses at the École Nationale des Arts Décoratifs, where he met Albert Marquet, who was six years his junior. The friendship between the artists would last throughout their lives. For both of them 1895 was a very important year because they both passed the entrance examination for the École des Beaux-Arts. Henri Matisse was now a regular student at the most important art academy in France. He regarded that as a major victory.

Two years previously, he had embarked on a liaison with the model Caroline Joblaud, and their daughter Marguerite was born one year later, in 1894. Matisse continued to take care of the child even after the end of his relationship with Caroline.

The earliest sculptural work by Matisse to have survived is a little medallion with a profile image of his daughter from 1903. He also painted her frequently. In the picture *Marguerite, Reading* from 1906 (opposite) he showed her absorbed in reading a magazine.

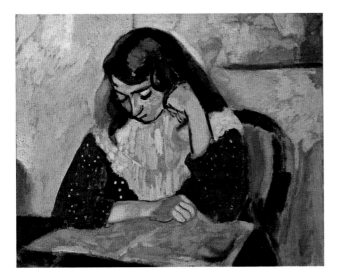

Marguerite, Reading, 1906

Student years and initial success

Thanks to his parents, Matisse was sufficiently well-off to be able to afford a flat with a studio not far from Notre-Dame, in which he would live until 1906. At the academy, he joined the class of Gustave Moreau: a stroke of luck for the art student. Moreau—who was already in his seventieth year—was an academic painter through and through, with a strong inclination towards Symbolism. His preferred subjects were biblical and mythological themes. He was receptive for the special talents of his students, but nevertheless encouraged them to copy the Old Masters in the Louvre. During the years he had spent travelling through Italy, Moreau had made an intensive study of Renaissance painting and had learned how to lend surfaces materiality, subtlety and a aura of preciousness. In spite of his great love for the painting of the Old Masters, Moreau was also interested in modern trends in French art, including Impressionism.

During his five years as a student, Matisse worked at lightning speed through everything

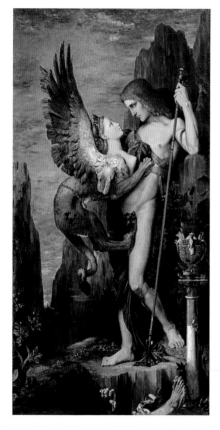

Gustave Moreau, *Oedipus and the Sphinx*, 1894 *Nude in the Studio*, 1899

that he came across in the way of contemporary art: academic fine painting like that of Moreau, Realism in the style of Édouard Manet, and the Impressionism of Pierre-Auguste Renoir as well as Neo-Impressionism in the manner of Paul Signac and Georges Seurat. A comparison between the painting *Oedipus and the Sphinx* by Gustave Moreau and *Nude in the Studio* by Henri Matisse shows that within just five years he had detached himself entirely from his teacher. He had progressed within the French art scene from the current and celebrated "Salon art" to the avant garde. What an achievement for a young artist just approaching thirty!

On 10 January 1898, Henri Matisse married Amélie Noellie Parayre, who was three years younger than him. We know relatively little about Amélie's childhood and youth. She grew up in Beauzelle, not far from Paris; her father was a teacher, and also the editor of the republican newspaper *Avenir de Seine-et-Marne*. Brought up by her parents to be independent, after her marriage Amélie was not willing to slip into the role of the middle-class wife. She was able to hold her own with Matisse as an independent partner, but she nonetheless ran his household with skill and energy as well as sitting as a model for the master artist.

The honeymoon took them to London, principally because Matisse wanted to see the major William Turner exhibition that was being held there. At the beginning of February, the couple headed for warmer pastures, much to Amélie's delight, when they travelled to Corsica.

At the end of 1899, Matisse celebrated his thirtieth birthday; because of his age he was now compelled to end his studies at the academy. This represented a major upheaval, and he was obliged to adapt to a completely new situation. His fellow students and artist friends were scattered to the winds, he himself was married and his wife was pregnant. He had no connections to the art market and so far, no collectors on whose support he could rely. He faced an uncertain future.

Matisse's son Jean Gérard was born during the same year, followed by Pierre a year later. The family was in a difficult financial situation. Matisse had sold virtually nothing and Amélie was frantically looking for a job. They decided to put their children into care. As Francoise Gilot—Picasso's lover, companion and muse during the years 1943–1953 reports in her autobiography, "it was normal for women who had to work to entrust their children to their grandparents. Jean Gérard's main carer as a small boy was his paternal grandmother. Pierre, who spent most of his early childhood with his mother's family, became very attached to his Aunt Berthe."

It was only after 1906 that the family's financial situation improved. The Russian patron of the arts Sergei Shchukin had become aware of Matisse and commissioned him to paint two large paintings: *Dance II* (pages 50/1) and *Music* (pages 52/3). Other collectors followed; the years of crisis were over and Matisse's financially secure position enabled him to leave the bustling metropolis and move to Issy-les-Moulineaux, a little village not far from Paris. He purchased a house there and

had a wooden studio built in the garden where he could paint undisturbed and teach his students (page 23). For his children, too, the situation changed. Jean Gérard and Pierre were now able to live permanently with their parents, and the family also took in Marguerite, who by this time was 12 years old. Amélie was a good mother to her and they later became close friends. In 1944 both women were arrested briefly under suspicion of having collaborated with the Resistance.

The Fauves

Françoise Gilot wrote of the Fauves: "The Fauvists countered the saucy eroticism of an Adolphe-William Bouguereau [Professor at the Academy] with the freshness and simplicity of profane lust." The pointed emphasis of the sentence is strong stuff indeed! So, who were the Fauves, these "Wild Ones", who revolutionised painting with panache from 1905 and left their indelible mark on the image of French Classical Modernism in a contest with other anti-academic tendencies? Fauvism is not a clearly defined style in which only the theoretical principles apply, that its supporters consider to be binding. Impressionists and Neo-Impressionists tackled academic tone-in-tone painting through the dissolution of form. Lines and dots of almost pure colour aimed to make the pictures glow and simulate light and shadow. People, landscapes and objects were formed by this light. Dispensing with academic contours, they acquired flowing forms in which the lines dissolved. The avowed Cubists gathered around Georges Braque, who

was interested above all in the simplification and plasticity of forms and a clear pictorial structure. All three groups had chosen their names themselves in order to distinguish themselves from the other contemporary movements.

The Fauves were quite different, however: they did not form a cohesive group: they had no binding artistic concept, and they did not even choose their name themselves. That originated in an incident that occurred during the 1905 Paris Salon d'Automne.

A number of the young artists who took part in the exhibition really only had one conviction which they all shared: colours should no longer follow the picture content and be as close as possible to nature, but should be the true subject of the painting and make the simplified forms glow. It was a revolution.

Collected together in one room, the pictures by Charles Camoin, André Derain, Kees van Dongen, Othon Friesz, Henri Manguin, Albert Marquet, Henri Matisse, Jean Puy, Louis Valtat and Maurice de Vlaminck provoked violent reactions in the audience. Also in the room, surrounded by the brash pictures which blasted all visual habits, was a classical bust of a woman by the sculptor Albert Marque. It induced the art critic Louis Vauxcelles to utter the wittily sarcastic comment "Tiens, Donatello au milieu des fauves" ("Look, Donatello surrounded by wild beasts"). When he repeated the observation or words to that effect in an article about the exhibition in the widely-read boulevard magazine Gil Blas ("a virgin among the wild beasts"), the painters whose works were on show

in that room more or less by chance acquired the name: "Les Fauves" (The Wild Ones).

The group organised its first joint exhibition from 21 October until 20 November 1905 in the Galerie Berthe Weill. The young artists still rejected the description "Fauves"; it only asserted itself during subsequent years and was accepted by all the members of the group from 1907. If we follow Françoise Gilot, "Fauvism was not a long-lasting artistic movement; it was restricted to the period between 1905 and 1909. Only Matisse remained committed throughout his life to the flame which was lit at that time."

The breakthrough: *The Joy of Life*

During the years 1903/4 Matisse still cultivated a highly realistic, concrete painting style with expressive features which is reminiscent of the early pictures of the German Expressionists. Matisse made skilled use of light and shadow to lend his figures three-dimensionality and volume and to emphasise spatial impressions. *Carmelina* from 1903 is one such example of this realistic-expressive style. It was only after Matisse had fully absorbed this painting technique that he could free himself from it, shatter it and unite form and colour in delicate interplay. When he painted *The Joy of Life* just one year later, even his fellow artists could hardly follow this sudden change of style.

Matisse was no longer interested in a realistic representation, in the coherence of proportions and the foreshortening, the three-dimensionality

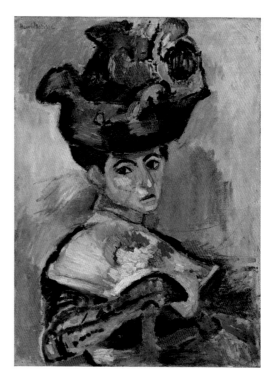

Woman with Hat, 1905

of forms. What fascinated him now was the visual presentation of the intellectual, the pleasure in beauty and the enjoyment of life in the widest sense. Formally, his concerns were rhythm, dance, light and colour. Matisse saw in *The Joy of Life* a key picture for what he was aiming to achieve.

The painting is the result of relentless work, the training of the eye, and manifold experience of life, linked with the determination to create something which was not only his very own but also unique. No wonder he called it *The Joy of Life*.

The picture was shown at the Salon d'Automne of 1906, where it was the subject of animated discussions. Some of his former companions were horrified. Seurat lamented the maestro's decision to abandon Neo-Impressionism and could not understand the fact that Matisse used "contours in red and green as thick as my fingers". Braque complained about his friend's final rejection of Cubism.

The interest of important art collectors in Matisse's work grew, however. Gertrude Stein and her brother Leo bought *Woman with a Hat* (page 17). It was at the Steins' home that Matisse and Picasso met for the first time in 1906. A friendship full of tense moments developed; after all, both artists were aware of their role as leaders of the avant garde and the merciless rivalry which this resulted in. Françoise Gilot wrote in her remarkable book *Matisse and Picasso. A Friendship in Art*: "At the beginning of their relationship they competed more or less openly for the favour of mutual friends like Gertrude Stein, her brothers Leo and Michael, Georges Braque, André Derain and Juan Gris. [...] Since they both enjoyed the status of demi-gods, each represented a unique challenge for the other."

In the meantime, the group of collectors continued to grow, and so, in 1907, Matisse met one of the most important Russian collectors and art patrons, Sergei Ivanovich Shchukin, through the Stein family.

The collector discovered Matisse's *The Joy of Life* in Gertrude and Leo Stein's apartment in Rue de Fleurus and was intoxicated by the picture. Shchukin was a connoisseur of the contemporary French art scene and had already purchased pictures by Paul Gauguin, Paul Cézanne, Camille Pissarro, Maurice Denis and Claude Monet. Matisse became his knowledgeable—and biased—mentor in matters relating to art. Over the next ten years, Shchukin went on to purchase more than forty of his pictures.

After the October Revolution of 1917, the textile manufacturer was dispossessed. He went into exile in Paris and left his art collection to the Tretyakov Gallery in Moscow. After the Second World War, it was divided up between the Pushkin Museum in Moscow and the State Hermitage Museum in Saint Petersburg, and serves as a crowd puller in both museums.

Henri, Bourgeois and Bon vivant: *Luxe, Calme et Volupté*

Despite having only been able to dream of a life full of "luxury, calm and beauty" during his early years, from 1906 Matisse lived in secure financial circumstances at least, which improved steadily.

Collectors and exhibition institutes became increasingly interested in him, granting him a considerable income which enabled him and his family to live an upper middle-class life. As early as 1907, he was able to move into a spacious flat with

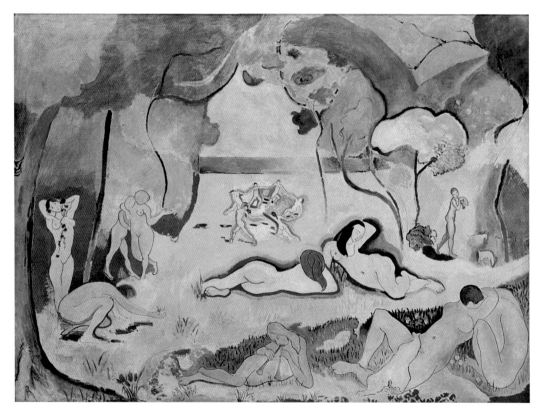

The Joy of Life, 1905/6

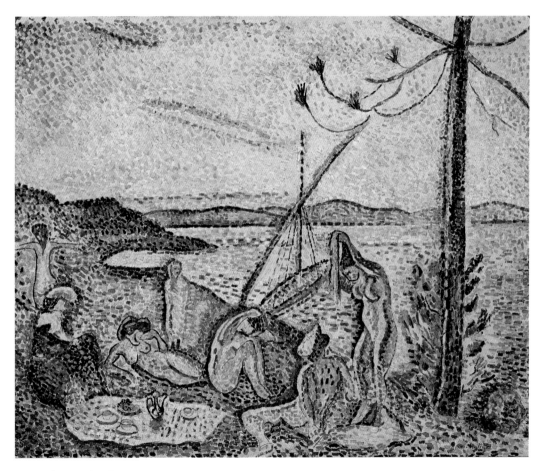

Luxe, Calme et Volupté, 1904

a studio on the Boulevard des Invalides; moreover, he could afford extended journeys and sojourns of increasing duration on the Mediterranean.

In 1906 he visited Algeria and then spent several months in Collioure, south of Perpignan on the coast near the Spanish border. He spent almost the entire next year there and also undertook an extended journey to Italy with his wife Amélie, during which he studied in particular the painting of the early Renaissance in Florence, Arezzo, Siena, Ravenna, Padua and Venice.

At the beginning of 1908 the artist founded the Académie Matisse. Numerous German students also enrolled there, including Oskar Moll, Rudolf Levy, Albert Weisgerber and Hans Purrmann, with whom a friendship developed which continued after Matisse retired from active teaching in 1910, when he devoted himself to his own artistic work once more.

Matisse handed over the directorship of the academy to Purrmann, who had attended the Kunstgewerbeschule (Arts College) in Karlsruhe and had studied in Munich with Franz von Stuck. Purrmann returned to Germany in 1914; between 1923 and 1928 he lived in Rome with his wife, the artist Mathilde Vollmoeller-Purrmann, and only seldom visited Germany. In 1935, the two artists left Germany permanently, albeit not of their own accord: Purrmann's art had been classified as "degenerate". The Purrmanns went to Florence and later to Switzerland.

From 1909 until the outbreak of the First World War, the Matisse family lived mainly in a villa in Issy-les-Moulineaux, on the south-western outskirts of Paris, which they initially rented. Immediately after they moved into their new home, Matisse had a studio building erected in the garden at his own expense (page 23); in 1912 he then purchased the entire property (page 23). Now he had created ideal working conditions for himself. He could paint undisturbed in the studio, which was in a separate building, but his home and the family were only a few steps away; and yet everything was close to the city but in a large garden.

At this point Matisse was already considered to be one of the most important protagonists of Modernism in France and in many countries of Europe. He always cultivated a neat appearance; his clothing was fairly conservative and dignified. Matisse's appearance and lifestyle were decidedly upper-middle-class. Important artists were tacitly granted the right to permissive love affairs, which were never discussed in public. Only Matisse's painting was regarded as revolutionary, whereby the glowing colours of the pictures and the delicacy of his elegant drawings, which were simply reduced to lines, found increasing admirers among the more progressive members of society.

The gallerist and publisher Paul Cassirer wanted to establish Matisse on the German art market and staged a major exhibition in Berlin in 1909 with the artist's sculptures and paintings. At the time, Cassirer was successful in selling works by the German avant garde, especially Lovis Corinth, Max Liebermann and Max Slevogt. The works of these artists lie between Impressionism and Expressionism and are full of earnestness and

strength. The public found Matisse's paintings too "light" and playful by comparison, not dramatic enough. The exhibition was not a success. His fame only started to grow in Germany during the course of the 1920s. In 1930, the Matisse exhibition in the Galerie Thannhauser in Berlin created a major stir among the public and the press alike, and he was fêted as the "painter-poet".

During the 1920s, Matisse mostly spent the winters in Nice, staying in various hotels, and from 1922 in his own flat on Place Charles-Félix. From 1931 until his death in 1954 he lived on the French Riviera in Vence and finally in Cimiez, a district of Nice, when he was not on one of his journeys, which could last for weeks or even months.

Le Grand Maître and his models

Caroline Joblaud

Caroline Joblaud called herself Camille and came from a humble home. Her father was a carpenter in the village of Le Veurdre in the département Allier in central France, where Caroline was born on 23 April 1873. After the early death of her father, she was brought up by nuns. She was of a practical disposition and made the best of her lot, learning to sew and becoming interested in fashion, even as a teenager. At the age of 18 she went to Paris, where she earned her living as a sales girl in a hat shop and by working as a model. As Hilary Spurling relates, "In 1892 she was just nineteen, a lively, graceful creature with a charming hint of fragility and vulnerability. [...] She was pale and slim, with long, dark hair and big, dark eyes." Matisse painted the young woman in his first studio on Quai St-Michel in Paris. At this stage Matisse was twenty-two and he immediately fell in love with the dark-haired beauty. Their daughter Marguerite was born in 1894; she initially lived with her mother because Matisse was a penniless student. The relationship with Camille soon fell apart.

Studio in the garden of the property in Issy-les-Moulineaux, 1910

Villa of the Matisse family in Issy-les-Moulineaux, garden façade, 1909/10

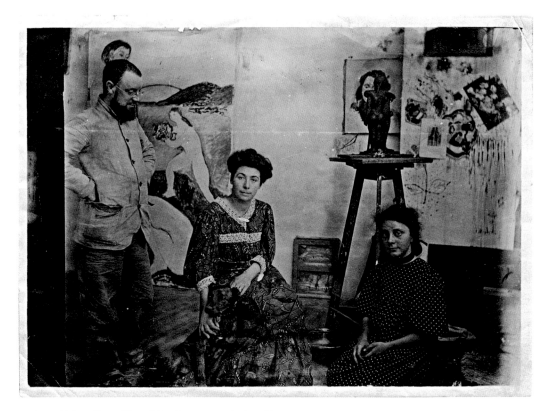

Matisse with his wife Amélie and daughter Marguerite in Collioure, 1907

Amélie Noellie Parayre and Marguerite—wife and daughter

After the marriage of Amélie Parayre and Henri Matisse in 1898 and the birth of their two sons Jean Gérard (1899) and Pierre (1900), and in agreement with Caroline Joblaud, the couple took in Matisse's illegitimate daughter, Marguerite, in 1906. Amélie was a good foster mother, and the two women later became close friends. Matisse often drew and painted them both. "Many young casual and professional models were unable to capture his attention for very long," as Françoise Gilot remembered. "Mostly he preferred to compete with stronger personalities. [...] He found these in his wife and devoted companion Amélie and in his daughter Marguerite [...]. These two proud, upright, unconventional women submitted with patience and inner resilience to the endless sittings and are correspondingly immortalised in numerous pictures. [...] Both women possessed an innate humanness and disposition; they were not pretty in a decorative sense—in a nutshell, they represented the very opposite of the passive, archetypal odalisque predominating Matisse's works from the 1920s."

Much later, in 1944, the foster mother and her daughter were arrested by the French police because they had been working for the Resistance. They only just escaped deportation to Germany and were released again in 1945.

Jeannette Vaderin

Jeannette Vaderin was a girl from a middle-class family who lived not far from the house that Matisse had purchased in Issy-les-Moulineaux in 1909. She acted as his model on a number of occasions; *Girl with Tulips* from 1910 (page 27) shows that Jeannette was precisely the type of woman that Matisse particularly liked and portrayed in many of his pictures: a face with finely cut features, a slim, graceful figure and dark hair. Two years later, Matisse embarked on a series of busts of Jeannette (pages 54/5). The first two versions were executed very much in the late-Impressionist style à la Rodin and preserved their similarity to the model. The three final versions, however, escalate into a harsh Expressionism and exaggerate all the subject's features in a way hitherto only encountered in the works of Picasso and the German Expressionists. Matisse refused to accept any criticism of this path, which would ultimately lead to abstraction. When the American journalist and collector Mildred Aldrich blurted out: "I don't understand it!", Matisse reputedly replied: "Moi non plus!" ("Neither do I!").

The Matisse family spent only five years living in the luxurious house that then went on to serve as officers' quarters during the First World War, while nonetheless remaining in the possession of the family. Today it houses the artist's archives.

Antoinette Arnoud

"She could be extravagant and sophisticated by turns; she could look seductive or as demure as a schoolgirl, and even when she was wearing nothing but a hat, she still succeeded in radiating a genteel dignity." Matisse engaged the 19-year-old Antoinette Arnoud as a model during one of his extended sojourns in Nice. During the years 1919/20 he was obsessed with the idea of capturing this woman in all her facets on canvas (page 28). More than sixty drawings have survived; he published fifty of them in a book titled *Cinquante Dessins* which accompanied an exhibition at Bernheim-Jeune in Paris.

Dina Vierny

Dina Vierny, née Aibinder, was born on 25 January 1919 in Chisinau, in what was then the Kingdom of Romania—present-day Moldavia. Shortly afterwards the family moved to Odessa and later from there to Paris. At the age of 15 she became the favourite model and muse of the 72-year-old Aristide Maillol.

Dina served as inspiration for some of his most impressive works, including the sculptures *The River*, *Air* and *Harmony*. Through Maillol she also met other younger artists, particularly Henri Matisse and Pierre Bonnard, for whom she also sat as a model. Françoise Gilot recalled: "Then she continued on to Cimiez, where Matisse received her with open arms and immediately started to draw. Maillol's attractive messenger had brought him a witty letter from the elderly master artist, in which he wrote: 'I am lending you the vision which fertilises my creativity, knowing quite well that you will reduce her to a line!'"

He commented to his new model, referring to the *Olympia* of Édouard Manet, whom he highly esteemed: "You will become the *Olympia* of Matisse!"

Even in old age, Dina Vierny was also a popular singer of chansons in France and in the resident Russian community there; in 1975 she produced her album *Chants Des Prisonniers Sibériens D'Aujourd'hui*, which is eminently worth hearing.

Olga Markova Meerson

Olga Markova Meerson was born in 1880 in Moscow, where she grew up in a middle-class Jewish family. She began to study art there before continuing in Wassily Kandinsky's Phalanx painting school in Munich from 1902 onwards. In 1908 she moved to Paris in order to become one of Henri Matisse's students. She was eventually successful in this endeavour, although initially Matisse wanted to get rid of her by (paradoxically) singing her praises, since he felt that by virtue of her academic training she was too strongly set in her ways. Accordingly, he confirmed that she had the gift of being able to paint amazingly accurate portraits.

Meerson, however, refused to be discouraged, and stayed. She became not only Matisse's student and model, but also his lover. In 1911 the two artists painted each other; Meerson showed

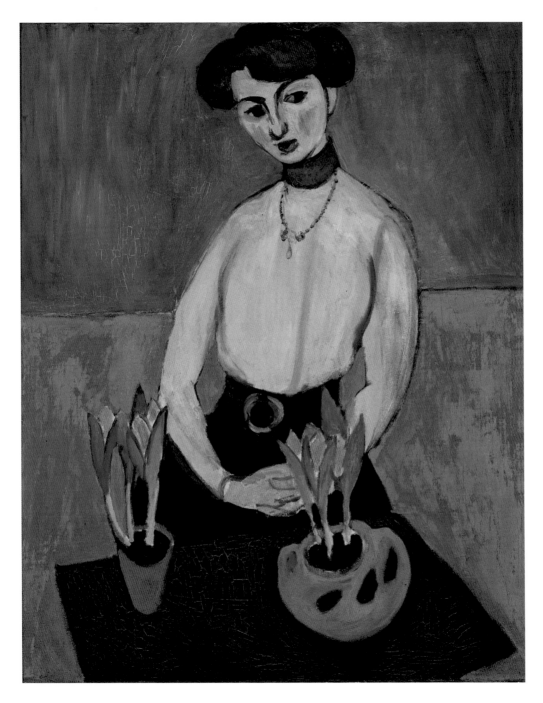

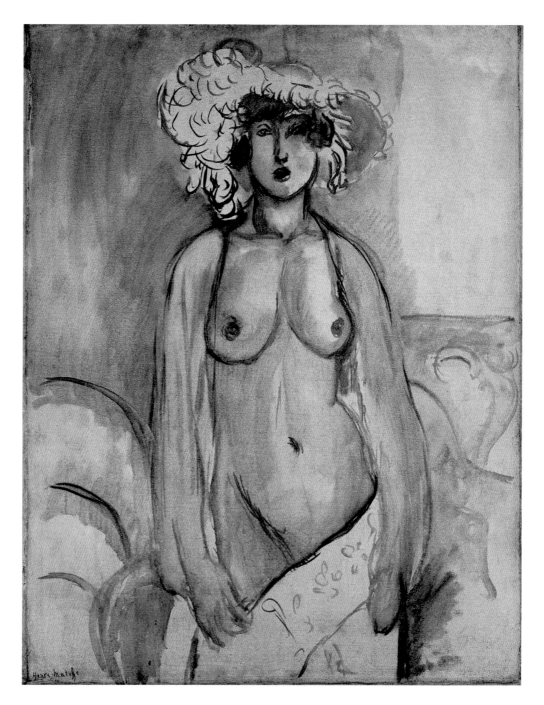

28

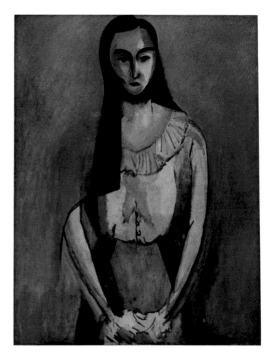

The Italian Woman, 1916

Matisse reading a book on his bed, while Matisse in turn painted Olga Meerson on a number of occasions. She was also his model for the sculpture *Seated Nude*. Nor did their liaison remain hidden from the artist's wife. She insisted that Matisse and Meerson should separate, and Olga returned to Munich. In 1912, she married the composer and conductor Heinz Pringsheim, who also had a doctorate in archaeology, and moved to Berlin with him. Their daughter Tamara was born in 1913, but the marriage was an unhappy one as the unconventional, independent and headstrong woman did not feel comfortable in the haut-bourgeois society to which the Pringsheim family belonged. She suffered from depression, and in 1929 she threw herself out of the window of her flat on the fourth floor of the Hotel Adlon in Berlin. After her death she was quickly forgotten.

Lorette

In 1916/7 Matisse devoted himself with great passion to two young sisters from Italy, Lorette and Annette, whose surnames have not been recorded. During this time the artist was struggling as never before to free his painting from its references to nature. He radically simplified his visual language, especially in his portraits.

His principal concern was to reconcile the definition of types which he had studied in the portraits of saints of the early Italian Renaissance and in Russian icons, with the individual traits of his models. In a long series of portraits, he worked through the subject and experimented with different degrees of abstraction, for which he also found inspiration in African tribal art.

He did not always paint Lorette in this rigorous manner, however. More than fifty times he also depicted her as a lovely odalisque or an austere Spanish woman, as an innocent girl or a Parisian cocotte—the young Italian woman clearly possessed considerable talent as an actress.

Henriette Darricarrère

After he had ceased working with Antoinette Arnoud at the end of 1920, Matisse concentrated entirely on his new model Henriette Darricarrère. He had met her while shooting a film in Nice, where she had been engaged as a film extra. Henriette worked as a dancer, played the violin,

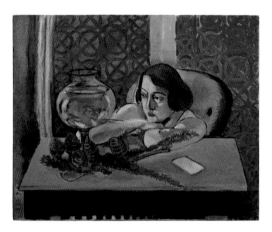

Woman in Front of an Aquarium, 1921

was interested in painting and was very similar to the type of woman Matisse sought for his pictures of odalisques. He accordingly drew her in various poses and painted her in red pantaloons, in transparent silk robes as well as nude. *Woman in Front of an Aquarium* assumes a special status within this group of works. Simply dressed and with her head resting on her crossed arms, she gazes into the goldfish bowl on the table in front of her. Concentration and a meditative mood are reflected in her face.

Matisse's daughter Marguerite became friendly with the young woman, and Amélie was delighted with Henriette since her husband evidently had no sexual ambitions towards her. She enjoyed the sincere affection of the family and wrote to her new friend Marguerite: "Oh, it does me good to see a loving family like yours."

Henriette was the model for the sculptures *Large Seated Nude I–III*, created between 1926 and 1929. Matisse painted the young woman several times (*Odalisque with Magnolias*, pages 70/1) and depicted her on drawings and lithographs (*Large Odalisque with Striped Trousers*, pages 72/3).

Greta Prozor

Greta Prozor came from a family of aristocrats and diplomats. Her father, Count Maurice Prozor, was the Lithuanian envoy in Paris, her mother the Swedish countess Marthe-Elsa Bonde. Her parents spoke several languages and could converse in many languages, some of which were Lithuanian, Russian, French and German. Count Prozor was not only a diplomat, but also a writer and translator. The couple had three children, Maurice, Greta and Elsa. Greta attended grammar school but wanted neither to study nor to get married. She wanted to become an actress.

The British writer and journalist Hilary Spurling described the painting very accurately: "Mademoiselle Prozor, a slender, angular figure, but bubbling with intensity, was a fascinating personality. [...] Matisse's preparatory sketches show her relaxed and happy, but on the oil painting she seems to have been transposed onto another plane of reality and looks strangely immaterial, even ghost-like: her lips are black, the flower in her hat looks like a dead beetle, and the pointed

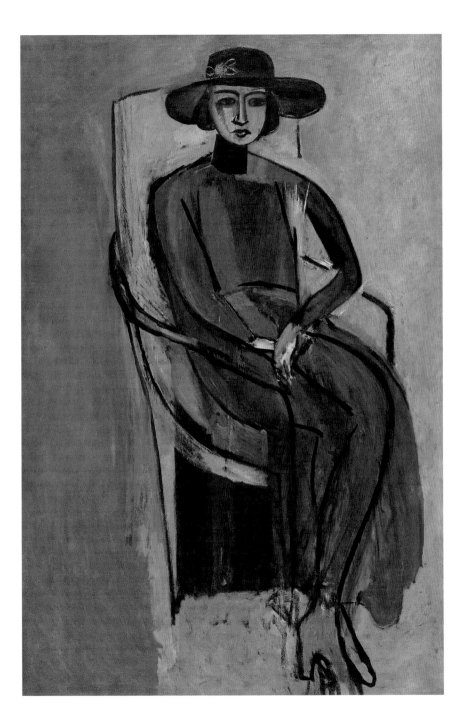

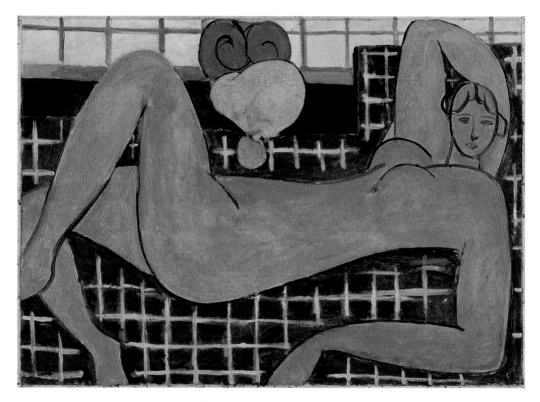

Large Reclining Nude, 1935

toes of her elegant, narrow shoes barely touch the ground, as if she were about to rise up into the air."

Lydia Delectorskaya

Lydia was born in Tomsk in Siberia in 1910 as the daughter of a doctor; nothing is known of her mother. The child was orphaned at an early age and grew up with foster parents. It says a great deal about her remarkable powers of self-assertion and iron will that she succeeded in setting out for Western Europe during the mid-1920s while still a teenager, somehow managing to struggle along until she reached Nice. There she made her living with casual jobs. She was 22 years of age when she applied for a job as a housemaid to the Matisse family. She was a good worker, and moreover, three years later she began to sit as a model for the master artist. Many of the artist's most significant compositions were created during this collaboration, including the *Large Reclining Nude* from 1935.

This painting is one of the first works in which Matisse used cut sheets of paper, a working technique that later became particularly well-known through the artist's famous paper cut collages.

Amélie Matisse watched the development suspiciously; after all, she had often experienced that the relationships of her husband to his models were also of a sexual nature. But Lydia declared from the outset that she would not tolerate any attempts at a sexual approach, and she kept her word. Nonetheless, Amélie watched the events very closely, because she had noticed that a close relationship had developed between the two. This was due to the fact that the artist, by now 65 years old, had discovered in Lydia a kindred spirit, who bravely and unwaveringly followed her own path as he, too, had once done. Lydia, who was just 25, wanted to see a father-figure in Matisse, no more and no less. She looked after him and conversed at length with him. She patiently resisted his bursts of rage and when nothing else seemed to help, she would threaten to return to Russia.

And so, although Amélie had no reason to object to this particular relationship on the part of her husband, she confronted her husband with the famous-infamous choice: "It's either she or I!" And although he submitted and dismissed Lydia, Amélie nonetheless left her husband in 1939 after forty years of marriage.

The strongest tie between Amélie and her husband had been the fact that for decades she had "taken care of everything" for him in all areas of their daily lives, also regarding business and organisational problems. She was a party to everything that he did and focused entirely on creating the best possible working conditions for him. Lydia had taken her place in Matisse's life in this respect, and she was unable to get over that. After his divorce, Matisse employed Lydia again. The young Russian woman cared lovingly for the artist, who by now was sick and frail. Just a few days before his death on 3 November 1954, he drew a last portrait of her in ballpoint pen.

Matisse and Picasso

If we study the developments in fine art in European countries during the twentieth century, it strikes us that only in France were there two artists who determined the entire era and outshone all their rivals: Matisse and Picasso. When considered separately each is in himself an entire universe reflecting all the existing and emerging art trends, reforming them, absorbing them into his own oeuvre and bringing them to fruition. Picasso began as a Late Impressionist, absorbing Expressive and Surrealist elements (Blue and Rose Periods), adapting the vocabulary of Surrealism, re-shaping it and subsuming it into his personal style. Together with Braque, he examined the possibilities of abstraction, then abandoned this route and developed in his late work an expressive, direct and "overwhelming" Realism.

Matisse, too, went through various metamorphoses and transformations during the course of his artistic life. They ensured that he was always at the focal point of developments, making him into a leading figure for many artists. Like Picasso, he began with a loosely Impressionist painting style that was strongly orientated towards a natural model. From this he developed his fundamental conviction that the three components light, colour and form were the basis for all good painting. Matisse began systematically to examine the relationships between these three components, arriving time and time again at striking results.

In 1918 the exhibition *Matisse—Picasso* in the Galerie Guillaume confirmed the leading role which the two artists then occupied in Paris.

Françoise Gilot and Pablo Picasso with their son Claude, c. 1952

Both knew well that they were each other's greatest rival within the French art world. Over the course of time, they left Georges Braque, their companion and colleague in early years, behind them, because he unswervingly clung to Cubism and honed its design possibilities, rejecting the idea of constant experimentation.

The richest contemporary source regarding this multi-faceted rivalry can be found in the records of Françoise Gilot. Her parents would have liked her to become a lawyer, but Françoise had other plans and insisted on carrying them out. In 1938,

she moved into her first studio in Paris, where she met Pablo Picasso, who was thirty-nine years her senior, in May 1943. They embarked on a relationship and from 1948 lived in Vallauris in the south of France. They had two children, Claude and Paloma, but nonetheless, Gilot ended her liaison with Picasso after five years and moved back to Paris with the children.

The journey to the South Seas: the key to Matisse's grandiose late work

Henri Matisse travelled a great deal as well as living for long periods in various different places. He had visited Brittany and Corsica as a young man, and in 1905 he spent the summer with his artist friend André Derain in Collioure. This village on the Côte Vermeille, the Vermilion Coast, in the South of France, continued to enthral him thereafter. Over the years to come he spent many summer months there. It was here that he visited George-Daniel de Monfreid and saw his collection of Gauguins, which certainly influenced his work. After all, Paul Gauguin had created brilliant works in the seclusion of Polynesia, which set standards above all in his trend towards the simplification of forms and his use of strong colours. Matisse was excited at the painterly rhythms of Gauguin's work.

In 1907, Matisse spent several months in Tuscany and Venice with his wife; in 1908 Germany was on the itinerary. In 1911 he visited his most loyal collector, the textile manufacturer Sergei Ivanovich Shchukin, in Moscow, and travelled to Morocco

The Music, 1939

for the first time. During the summer of 1917 he lived and worked for several weeks in Nice; the sojourn there by the sea became a regular part of his travel plans during subsequent years and he eventually spent almost every winter there. From 1938 he lived for most of the year in Cimiez, where he had purchased a flat with a large studio in the former Hotel Régina.

In February 1930 Matisse abandoned his usual travel habits and set out alone for Polynesia. The journey by ship took him via New York and San Francisco to Tahiti. When he finally arrived

in the "earthly paradise" he found "pure colour: diamond, sapphire, emerald, turquoise", but the monotony of the days, the dazzling light, the idleness and the endless sea lamed instead of inspiring him.

He complained that he was unable to work and that he had produced nothing except a few poor photos. Only after he was back at home would it transpire that, being torn away from all his usual habits, the foreign and exotic colours and shapes, as well as the voyage across that apparently endless sea, had moved something within him. If we follow the art critic and writer Hans-Joachim Müller, Matisse, in the South Seas, was "surrounded by pure light, pure air, pure colour. Here he had absorbed the soft forms and supple, swaying bodies, the wafting hair, the finger-like seaweed and the meandering outlines of leaves which would determine his late work."

His paintings from the 1930s and 1940s are as powerful as they are coherent. Matisse discovered how to create a wonderful synthesis of ornamental drawing and painting across a large area, for example in his picture *The Music* from 1939 (page 35).

However, painting was becoming increasingly difficult. Matisse's work on canvas was not only an intellectual challenge, but also a major physical effort. And so, with Lydia's help, he painted large areas of paper with gouache paints, preferably blue, and cut out the curious forms from which he composed and glued human figures, flowers and fanciful water creatures.

These collages radiate joyful tranquility and serenity; their entrancing beauty and quiet pleasure in life reflect the atmosphere and light of the tropics and delight the viewer. It seems as if the sick old man, faced with death, insisted on showing his audience once more the beauty of the world, the value of life, the power of friendship and the joys of love—at the same time both an admonition and a summons.

Matisse working with Lydia Delectorskaya on "The Oasis" in his studio in 1952

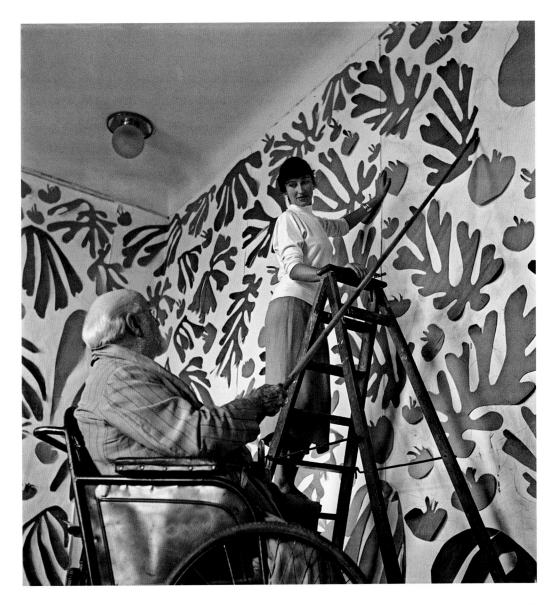

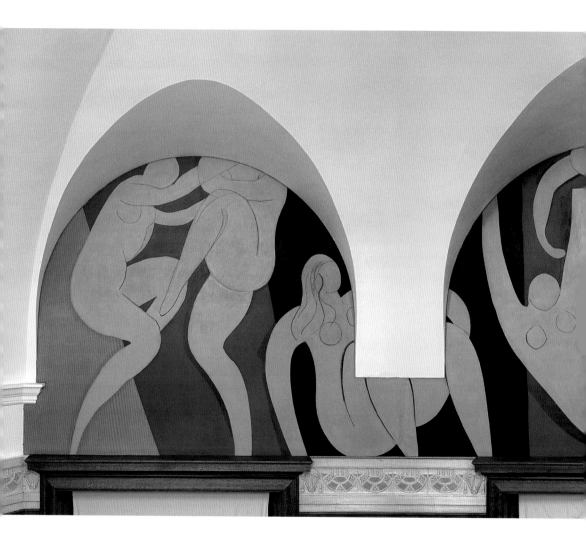

WORKS

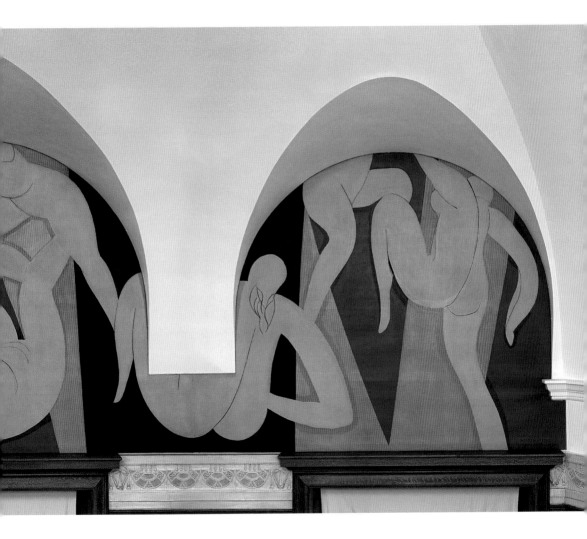

Sailor II (The Young Sailor), 1906

Oil on canvas
101.6 × 83.2 cm
The Metropolitan Museum of Art, New York

Matisse painted two versions of *The Young Sailor* in 1906. Under the influence of Georges Braque and Pablo Picasso he gave Cubism serious thought but continued to pursue his own highly nuanced style of brushwork. His concern was not exclusively the reduction of painting to geometric forms and the development of the three-dimensional form of an object; Matisse also valued the realistic portrayal of the face and the characterisation of his model, to which the latter's casual posture also contributed. For him these components were at least as important as the unadorned sculptural shaping of the body.

The colour scheme of the picture is determined by reducing it to dominant shades: a bright green, dark blue and pink. The forms are even more clearly defined, and the contours sharper than in the picture *Sailor I*; they enclose and structure the areas of colour. Here Matisse succeeds in achieving a masterful synthesis of Cubistic simplification of form, liveliness of expression and "Fauvist" colourfulness. Thus, even in this early picture he formulates the three key parameters and boundaries of his painting, between which his entire oeuvre would operate.

For Françoise Gilot the picture prompted memories of her time as a teenager: the young sailor "reminded me of a playmate whom I had once met during a holiday in the South of France. [...] We began to wrestle in the fine sand, just for fun. A spicy aroma emanated from the boy's red hair and mixed with the sickly perfume of crushed narcissi—suddenly I was overwhelmed by such a pleasant, surprisingly new feeling that I wished I could faint. We lay motionless, gazed into each other's eyes and smiled at each other in that unfathomable way that can be observed in young people as soon as they step into the unknown territory of adult emotions. In this picture Matisse has captured precisely this *fureur de vivre*, this basic instinct which drives young people forwards on their way into the Garden of Desire."

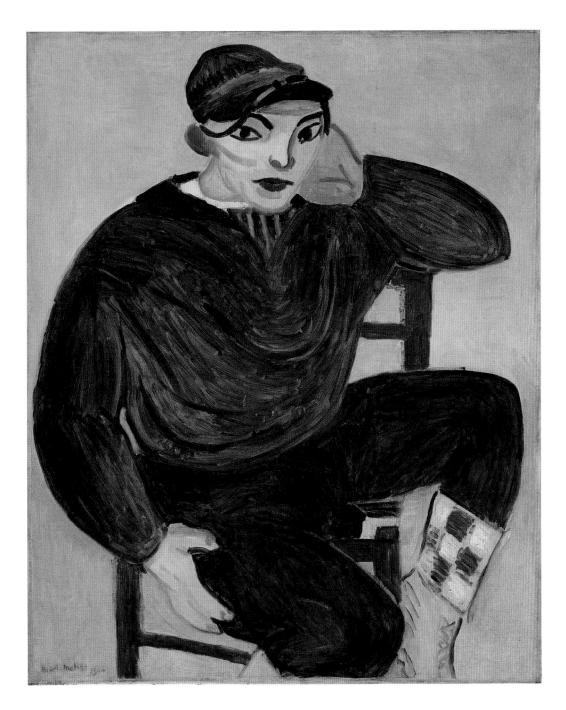

Marguerite, 1906/7

Oil on canvas
65 × 54 cm
Musée Picasso, Paris

How did a picture by Henri Matisse find its way into the Picasso Museum? As a gift from one artist to the other. Matisse and Picasso were friends, but as artists, they were also rivals. This portrait, created in 1906/7, shows Marguerite, the daughter of Henri Matisse and his model Caroline Joblaud. It was at this time that the artist received his first noteworthy commissions and was able to afford professional models for the first time. It is no secret that it was very important for Matisse to establish personal and whenever possible intimate relationships with the women with whom he worked; for him this was a necessity if he was to be able to paint them convincingly.

Although the artist did not marry Caroline Joblaud, he took care of their daughter. In 1898 he married Amélie Noellie Parayre, with whom he had two sons. Jean Gérard was born in 1899; he followed in his father's footsteps and became an artist. Pierre was born one year later. As a young man he emigrated to the United States, where he lived and worked successfully as a gallerist in New York and managed his father's work.

The illegitimate Marguerite was taken into the Matisse family at the age of 12. Her relationship with her stepmother Amélie was relaxed, even warm, and Marguerite was accepted by all the family members.

Matisse loved his daughter dearly and painted her—and his wife Amélie—on frequent occasions. In the portrait from 1906/7 she is wearing a green dress and has a broad velvet ribbon around her neck. As Picasso's companion Françoise Gilot related, "Picasso hung the painting in his bedroom, so that the artist's [Matisse's] daughter could follow us with her gaze like a guardian angel. Matisse had painted her name in large letters on the picture and gave it to Picasso shortly after its completion."

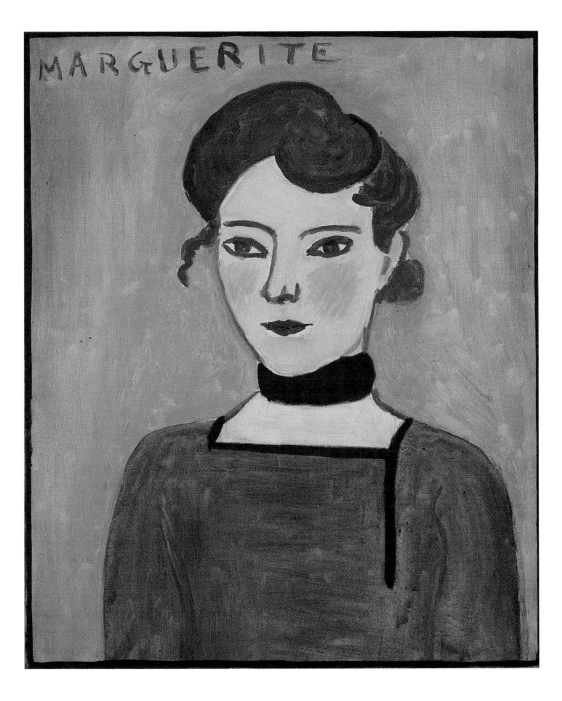

Harmony in Red, 1908

Oil on canvas
180.5 × 221 cm
The State Hermitage Museum, Saint Petersburg

This picture could also be called "The Discovery of Ornamentation". Were it not for the view from the window, which suggests a certain spatiality, the picture would purely consist of a uniform red surface covered with ornaments. The wall and the table have both been painted in the same intense shade of red and are covered with blue ornamental forms that run seamlessly into each other. The seated figure of a woman and the objects on the table are also arranged equitably within the picture structure. In order to heighten the two-dimensional character of the painting still further, there are no overlaps between the objects; at best, we could speak of "contacts". Matisse was aiming for a one-dimensional appearance in the picture and carried it to extremes by the total lack of shadows. A popular saying maintains that "Where there is light there is also shadow,"—only ghosts do not cast shadows. By dispensing with shadows, Matisse makes all the objects in the picture—the carafes, plates, fruits and flowers—into insubstantial ornaments. It is his first step towards abstraction. He will pursue this route, examine it for its suitability with regard to his artistic intentions, and then, finally abandon it.

The picture was on view at the Paris Salon d'Automne in 1908, albeit entirely in blue and correspondingly bearing the title *Harmony in Blue*. When the painting arrived a year later in Moscow at the home of the collector Sergei Ivanovich Shchukin, who had purchased it, it was gleaming in dark red: the artist had painted it over entirely. It is easy to imagine the surprise of the textile manufacturer and influential merchant, but in his boundless enthusiasm for Matisse and the Fauves he raised no objection. The collector bequeathed the picture while he was still alive to the State Hermitage Museum in Saint Petersburg. Founded in 1764 by Catherine the Great, the museum houses today one of the most important collections of European painting of Classical Modernism, including thirty-seven works by Henri Matisse and thirty-one by Pablo Picasso.

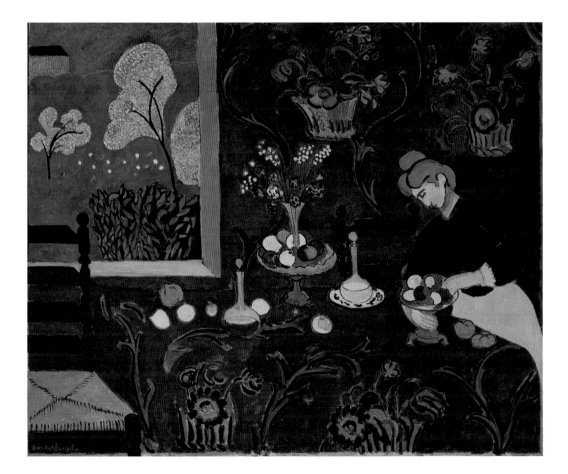

The Algerian Woman, 1909

Oil on canvas
81 × 65 cm
Musée National d'Art Moderne, Centre Pompidou, Paris

Matisse had become friendly with the German artist Hans Purrmann, whom he also persuaded to become a member of staff at his Académie Matisse. In 1908 they travelled to Germany together, visiting Berlin and Munich. The main aim of the journey was to acquire gallerists and establish contact with collectors. There were also a number of fruitful encounters with German artists. Ernst Ludwig Kirchner energetically claimed that no one would be able to learn anything from Matisse, but nonetheless his *Reclining Nude with Fan* from 1909 shows clear similarities with Matisse's painting style. His forms were becoming more free-flowing and softer, and the harmonious arrangement of the colours was also reminiscent of Matisse. In Murnau during the previous year, Wassily Kandinsky, Franz Marc and Gabriele Münter had already developed the preconditions for the pioneering style of *Der Blaue Reiter*. Hilary Spurling comments: "It was only after this breakthrough that Kandinsky began to regard Matisse as one of the greatest living artists; and it was thanks to Münter that the revolution in painting which Matisse had brought about—and that she had been the first to understand—had an effect on the others."
The influence also worked in the other direction, however. After his return to Paris, Matisse painted a picture, *The Algerian Woman,* that had nothing in common with his previous explorations of ornamental forms. The figure has been structured entirely in the manner of the German Expressionists; the colours extend across large areas, and the lines appear considerably harder than those which we have previously encountered in the works of the famous French artist. The dark contours lend the face and body an aura of gravity and austerity. Matisse dispenses almost completely with ornamental features, eliminating in this creative phase all engaging and playful aspects from his pictures and heightening instead the degree of abstraction in his depictions.

Back (Nu de dos) I, 1909

Bronze
191 × 116 × 13 cm
Musée Matisse, Nice

Matisse is regarded as what we could call an "artist through and through". The aim of all his efforts was to enter new, uncharted artistic territories and to paint pictures time and again which questioned everything that had already been achieved. He was not so much interested in new subjects, but rather in new forms of representation. He examined everything he encountered with regard to its suitability for his own development.

It is in this context that his small number of sculptural works should also be contemplated. He initially focused his attention on the relief, in other words the three-dimensional form which, as a result of its flat background and rectangular format, was most closely related to painting. The female nude is seen here from the rear and stands out almost like a sculpture against the slightly structured background of the relief. The woman is leaning against a wall, her head in the crook of her arm.

The relief reflects Matisse's study of the works created by the sculptor Aristide Maillol. The latter, who was eight years older than Matisse, was one of the most famous artists in France at the time. In 1904 the art-loving diplomat, patron of the arts and writer Harry Graf Kessler had commissioned the seated nude, *La Méditerranée,* from Maillol, which was shown at the Paris Salon d'Automne in 1905. Henri Matisse enthused about her simple corporeality and calm elegance. This realistic nude became the starting point of his further development towards abstraction a fact which applied not only to his sculptures but also to his painting. It is surely no coincidence that the posture of the nude woman in his relief almost perfectly matches the nude figure which Paul Cézanne depicted in his painting *The Bathers* from 1892. Matisse bought the painting in 1899 and is expressing his veneration for the artist, who was thirty years his senior, and whom he rightly saw as his direct "predecessor".

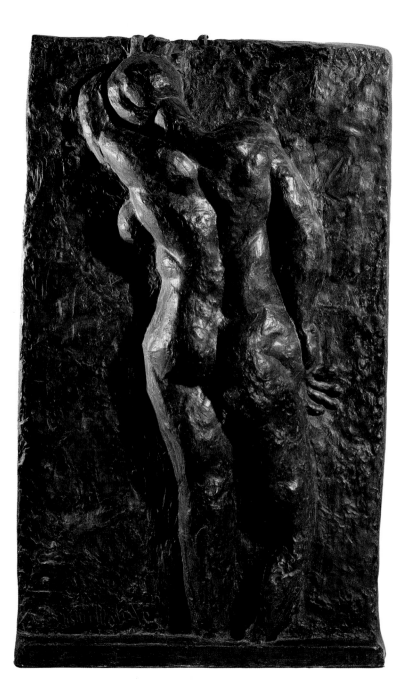

Dance II, 1909/10

Oil on canvas
260 × 391 cm
The State Hermitage Museum, Saint Petersburg

The grandiose German novelist and playwright Leonhard Frank (1882–1961) is credited with having coined the phrase: "Art means omission." That can also apply to Matisse's works *Dance II* and *Music* (pages 52/3).
In these two paintings, the artist translates the experience which he had acquired from sculpture onto canvas. He aims to depict movement and rhythm without any additional narrative. Matisse has eliminated everything that does not serve the convincing portrayal of his subject. Against a monochrome blue background, which reveals only minimal nuances, the dancing figures are moving on a green hemisphere which has been painted in a series of rhythmic curves. The bodies are clearly outlined, suggesting concentration. An unknown music whips them along, driving them in the swirling circle; the world around them appears submerged. Even the anatomy of the figures has been subordinated to the master painter's artistic aim. The figure with its back to us in the foreground is ruthlessly mis-drawn, but in precisely this form it creates the coherent link to the other dancers. Matisse sacrifices the "accuracy" of this one figure, in order to thereby, consistently and convincingly, represent the whole, the circle of dancing figures and the rhythm of the movement.
The picture was overpainted several times and was mostly greeted with incomprehension on the part of the critics. Only the private scholar, lawyer and oriental specialist Matthew Prichard, who had come to Paris in 1908 in order to study contemporary French painting, recognised what Henri Matisse was striving to achieve: "Much of what Matisse gives us is to be found in our subconscious lives. [...] In order to find out what it is, we must immerse ourselves in a state of trance or ecstasy; we must swim along the bottom of the stream of our existence."

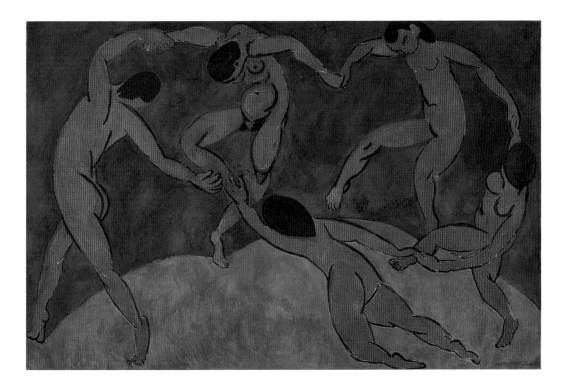

Music, 1910

Oil on canvas
260 × 389 cm
The State Hermitage Museum, Saint Petersburg

Music was created during the period 1909/10, at more or less the same time as *Dance II* (pages 50/1). The two pictures commissioned by the Moscow collector Sergei Ivanovich Shchukin were planned as companion pieces from the beginning and are formally very similar in style: the radical simplification of the figures, the choice of colours and the two-dimensionality of the paint application match each other completely. Matisse also chose the same format for both pictures. While the viewer of *Dance II* has a slightly elevated view of the scene (one third foreground, two thirds background), for *Music* Matisse selected a slightly lower angle in which the ratio between foreground and background is exactly reversed: here the foreground occupies about two thirds of the picture. The painter needs this space in order to distribute his figures like notes on a sheet of music. While the male or female sex of the figures is discernable in *Dance II*, in *Music* the protagonists are completely androgynous. The two figures on the left are clearly musicians; the standing figure is playing the violin and the seated one is blowing into a shepherd's pipe. It is left to the imagination of the viewer to decide whether the other three are rapt audience members listening to the music with their mouths half-open in amazement, or whether they are accompanying the instrumentalists in song.

The public reacted to the two pictures with almost universal incomprehension. And even the professional art critics—including those who were interested in modern painting trends—shook their heads helplessly at the works. After a visit to Matisse's studio to see *Music*, the New York art critic Henry McBride wrote in a letter: "I was totally unsure whether the vast picture was intended as a joke or whether it represented a serious attempt to create something beautiful."

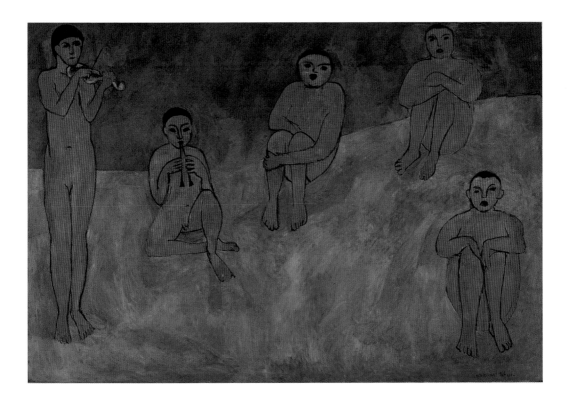

Jeannette II, 1910

Bronze
26.5 × 22.5 × 24 cm
National Galleries of Scotland, Edinburgh

The five busts *Jeannette I–V* were created between 1910 and 1913. The model for the first two heads in the series was Jeannette Vaderin (page 25). She was the daughter of a well-to-do couple who lived not far from Matisse's studio in Issy-les-Moulineaux, at that time an independent little village near the capital; today more than 16,000 people live in this suburb of Paris. The village's name refers to the numerous windmills which were to be found in the region. In 1909 Matisse had moved here into a house with a large garden and had a studio built in the grounds (page 23).

The first head he produced bears a close resemblance to the model. Its treatment of surfaces follows late-Impressionist criteria as expressed universally by Auguste Rodin in his wonderful female nudes. Both the portrait-like quality and the freely shaped surface are treated on an equal level and aim above all to permit the interplay of light on the sculpture. This also applies in essence to the second bust *Jeannette II*, although here there is a marked concentration on the face. The hair is portrayed with fewer nuances and the ears and neck have disappeared; nothing should distract the viewer from the facial features.

After this version, a radical break followed: the busts created during the years 1911–1913 become distanced from the natural model to such a point that they are no longer recognisable. The artist simplifies the forms and increases the facial expression until it becomes grotesque. The hair turns into rolls and spherical shapes; only dark hollows remain of the eyes, and the nose grows into a real "snout". With this deformation of the natural model Matisse is embarking on an artistic direction which his friend and rival Pablo Picasso would pursue to utter perfection.

Matisse earned little recognition from his fellow-artists for the *Jeannette* series. Nor was the momentousness of his experiments recognised within the circle of his family and friends, who also expressed this fact by generally referring to *Jeannette V* as "The Tapir" because of her grotesquely elongated nose.

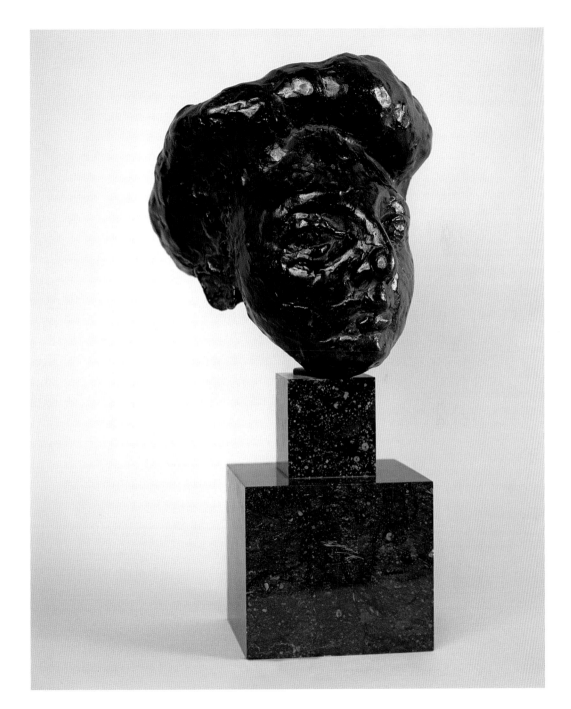

The Red Studio, 1911

Oil on canvas
181 × 219.1 cm
The Museum of Modern Art, New York

As in the case of *Harmony in Red* (pages 44/5) the entire picture appears to consist of a dark red surface, across which a variety of lines and objects have been distributed. Only upon closer inspection do we notice that the thin, light-coloured lines indicate a space. A table and a chair underline the impression of a room which nonetheless remains strangely imprecise. The picture contradicts all our visual habits. On the walls, the pictures are in some cases shown in perspective, while in others they are suspended and apparently disembodied in the air in front of the wall. The table and chair are also portrayed three-dimensionally, while the grandfather clock and the chest of drawers, by contrast, appear to be bodiless and drawn, as it were, on the wall. The objects on the table seem to be hovering. A wine glass, a hookah and a painted ceramic plate can be discerned, together with six crayons, neatly lined up on a sheet of paper.
Light-coloured pictures are hanging on the wall or stacked up against it, forming a marked contrast to the dark red. One of the pictures can definitely be identified as *Sailor II* from 1906 (pages 40/1); it is hanging in the top row in the middle of the space.
Since no easel can be seen, we can assume that the picture has been painted from the artist's point of view, and that he is sitting in front of it. So, he is "present", although he remains unseen. Can we interpret the picture as the representation of a dream—or is it one of the artist's many attempts to break through the constraints of realistic representation and to formulate his own reality, determined not by physical laws such as gravity and spatiality, but deriving solely from the imagination and perceptions of the artist, thereby lending the picture a reality of its own which exists independently from ours? In such a case, we can allege that the artwork itself is autonomous.

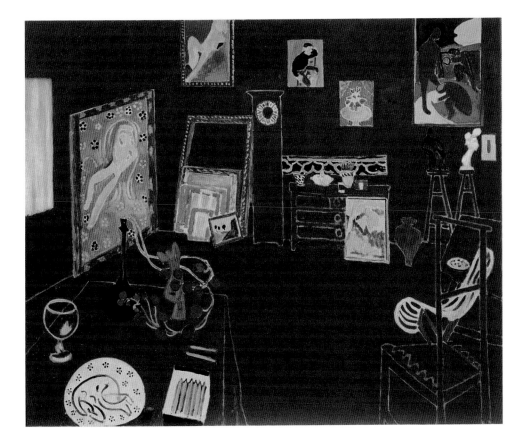

Spanish Still Life, 1911

Oil on canvas
89,5 × 116,3 cm
The State Hermitage Museum, Saint Petersburg

After a successful major exhibition in the Galerie Bernheim-Jeune in Paris, Matisse
participated in the Paris Salon d'Automne in 1910 with his two large-format paintings
Music (pages 52/3) and *Dance II* (pages 50/1). Both pictures were greeted with total
incomprehension by the public and provoked precisely what is known today
as a "shitstorm".
Matisse was both shocked and annoyed, and fled to Spain. He spent the winter in
Seville, where he had difficulty regaining his equilibrium. He began to paint in his
hotel room, and it was here that he created the painting *Spanish Still Life*. Inspired
by the patterns of the tablecloth and the fabric used for the cover on the sofa, he
focused his entire attention on ornamentation, revelling in the invention of ever-new
patterns and forms that covered the table and sofa and made them almost invisible.
The objects on the table also fitted into the ornamental arrangement. While the
flowerpot and water carafe are still fairly easy to make out, the peppers and fruits on
the table virtually disappear into the ornamental hotch-potch.
With regard to the colour scheme, the picture thrives on the contrast between warm
and cold shades. Matisse has reduced his palette. The main contrast is formed by dark
blue, sometimes bluish-black hues and the smooth, dark red wall in front of which the
sofa stands. Reddish-brown ornaments decorate the tablecloth, while those on the
sofa covering are yellow.
The picture is to be found today in the State Hermitage Museum in Saint Petersburg,
in those days the place of residence of Sergei Shchukin, one of Matisse's most
important collectors. His passion for modern French painting was ridiculed at the
time; nowadays his collection forms the nucleus of the Classical Modernism holdings
in the museum und draws thousands of visitors to the city on the Neva every year.

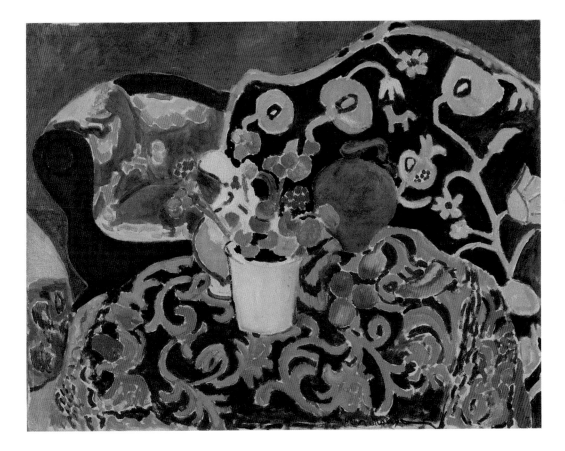

The Palm Tree, Tangier, 1912

Oil on canvas
117.5 × 82 cm
National Gallery of Art, Washington, D.C.

Matisse spent the November of 1911 in Moscow visiting his patron and collector
Sergei Ivanovich Shchukin and studying the extensive icon collection of his artist
colleague Ilya Semyonovich Ostroukhov, who was a student of Ilya Repin, the most
important painter of Russian Realism.

In mid-December, Matisse returned to Paris but left again at the end of January 1912,
this time with his fellow artist Albert Marquet to travel to Morocco. They remained
there until April, and in September Matisse again spent several weeks in Tangier.
He went into raptures at the luxuriant vegetation in the garden of his hotel and in
the city's public gardens. He was driven by the will to record the beauty of nature
accurately, and painted park scenes with trees, shrubs, expanses of grass and
flowers. The resulting late-Impressionist pictures radiate great harmony.

But even here, Matisse could not resist his urge towards abstraction, as we can see
in *The Palm Tree, Tangier*. Although the balance of colours has been preserved in
the picture, it does not offer the eye a perspectival view; there is no atmospheric
mood and most definitely no oriental ambience. Vegetal forms permeate the
picture against areas of tranquil colour; fan-shaped palm leaves, trees and vines
can be guessed at rather than recognised.

Three years after the picture was created, it was purchased by the socialist
politician and journalist Marcel Sembat. He collected works by the French avant
garde and was a friend of Albert Marquet, Paul Signac and Odilon Redon.

The politician wrote of the picture: "It was reworked three times [by the artist]
and developed each time one step further towards tranquility, towards abstract
simplicity. When I saw it for the first time, it showed the trees and grasses on the
ground in their former lives. Then the ground melted into several monochrome
areas of colour, the grasses became a garland of lianas, and the trees were
transformed into growths of an earthly paradise."

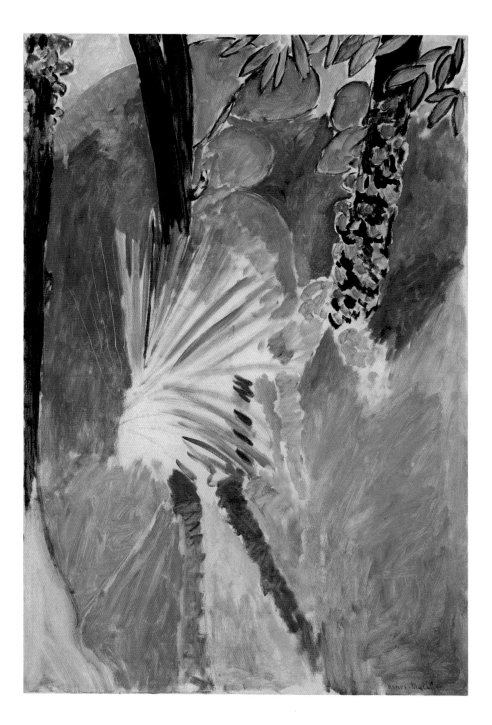

Lorette in a White Turban, 1916

Oil on wood
35 × 26.5 cm
Museum Collection Rosengart, Lucerne

In 1916 Matisse made an in-depth analysis of progressive French painting of recent decades, studying the works of Corot, Renoir, Monet and Cézanne. He examined their painting techniques in the hope of finding inspiration for his continued work. He was fascinated by Camille Corot's *Forest of Fontainebleau* with a young woman lying on a meadow of flowers. Matisse believed he had found a similar beauty in the young Italian woman Lorette. During the years 1916/7 Lorette, whose family name is not known, progressed to become the artist's favourite model. She was a cheerful, uncomplicated girl and knew how to slip into all the roles that the master artist asked of her. In her extensive and detailed biography of Matisse, Hilary Spurling describes at length how important his work with Lorette was for the painter's further artistic development: "He reacted to Lorette like a dancer allowing himself to be led by his partner with joyful attentiveness. She released in him a spontaneity which had been suppressed by years of assiduous, selfless exertion. He set to work energetically and painted her from curious angles and in exotic costumes, but he mostly returned to her simplest pose. He had her don a plain-coloured, long-sleeved top and sit down in front of him, her face turned in his direction, in order to improvise a long series of rhythmical variations on her heart-shaped face with the distinctive features and the thick black hair."
During the years 1916/7 Matisse painted over forty pictures of Lorette. The intensive cooperation between the two ended—as so often for Matisse—in an affair. "The relationship developed the obsessive, strenuous intimacy of a love affair which unfolded its greatest intimacy on the canvas, regardless of what may have happened in the breaks from work."

The Piano Lesson, 1916

Oil on canvas
245.1 × 212.7 cm
The Museum of Modern Art, New York

This picture belongs to a phase in Matisse's creative work that Gilles Néret described as "the attempt at abstraction". After all the ornamentation, the beautiful women, the oriental carpets and rhythmical compositions like *Dance II* (pages 50/1) and *Music* (pages 52/3), the artist was searching for new means of expression. Perhaps he was also driven by a fear of falling behind the developments of contemporary art. "Absolute Painting", which rejected the realistic representation of the world, was advancing steadily. In Germany as early as 1910, Wassily Kandinsky had abandoned every last trace of representationalism in his *Improvisation 13* and had pressed forward with abstraction. In France, Picasso and Braque achieved a similar high degree of abstraction with their so-called Analytical Cubism.

So far, Matisse had not been able to rouse any enthusiasm for the new movement; his experiments in this respect look decidedly lacklustre. If we compare the two pictures of his muse Lorette from the year 1916 with each other (page 29 and pages 62/3), his attempts at the simplification and geometrisation of forms look somewhat helpless. By contrast, *The Piano Lesson* from the same year appears to be a balanced and convincing composition. Here the interaction between plane and space reaches a new climax. Matisse engraves strips and lines into the large, smooth expanses of colour to suggest a certain three-dimensionality. The occasional ornamental elements—the music stand on the piano and the balcony railing—enliven the picture. Moreover, in the bottom left-hand corner we can recognise the *Decorative Figure* from 1908 and at the top right a highly simplified figure of a woman on a stool. On the expensive Pleyel grand piano—Matisse cannot resist adding the maker's name in mirror writing but easily legible—stand a solitary metronome and a lamp. The pupil could be his son Pierre. Or possibly the memory of his own piano lessons, endured under sufferance during his youth.

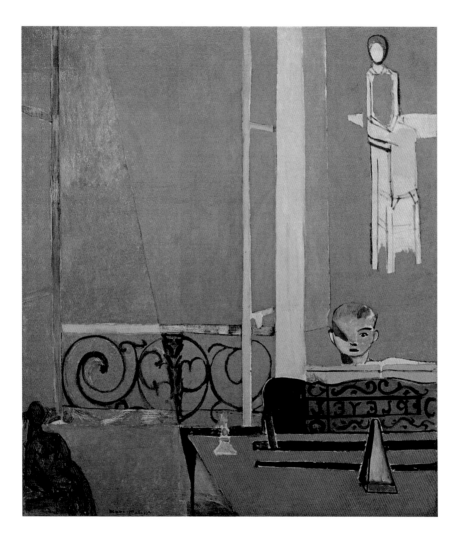

Interior with Black Notebook (Nice, cahier noir), 1918

Oil on cardboard
32.5 × 40 cm
Private collection

In January 1918 Matisse was sojourning in Nice, where he was staying in the Hotel Beau-Rivage directly behind the beachfront promenade. Also here people's thoughts and conversations were dominated by the events of the First World War. The German army was advancing on Paris, and on 23 March the long-distance shelling of the city began. "Nice is engulfed in a wave of panic," Matisse wrote that same day to his wife. The German offensive came to a halt, however, so that his daughter Marguerite and his son Pierre were able to leave Paris and make their way to Nice. His wife Amélie remained in the capital and attended to the safe-guarding of the family's valuables and her husband's paintings.

It was during this time that the *Interior with Black Notebook* was created. It is certainly not a cheerful picture. The space is dominated by finely gradated shades of grey, and outside on the promenade the people are only discernable as black, shadow-like figures. A black book is lying on a little table beside the open door. Since Matisse was occupied during this time with the compilation of a hand-written catalogue of the paintings in Issy-les-Moulineaux, which was to be completed before the pictures were put into storage, it is quite possible that this is that very list.

In April Matisse succeeded in renting a flat in the immediate vicinity of the hotel and equipped it as a studio with his children's help. His delight at the improvement to his working situation did not last long, however, because the hotel and the neighbouring buildings were requisitioned by the French army. Matisse and his son Pierre found new accommodation not far from Nice. They were able to rent a flat in a villa in Alliés that had a view into the distance across the town and coast towards Antibes. In spite of the adverse conditions in the country, Matisse had once again succeeded in arranging his working environment in such a way that it was possible for him to paint in peace and concentrate fully on his art.

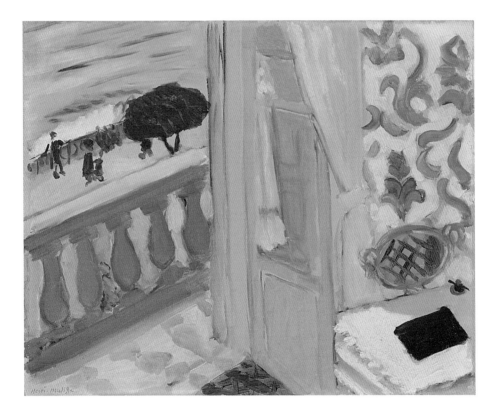

The Black Table, 1919

Oil on canvas
100 × 81 cm
Private collection

After the end of the First World War, Nice became Henri Matisse's main place of residence. He generally stayed there from the beginning of autumn until the spring, and sometimes even into the summer months. His wife Amélie was often with him and his sons and Marguerite also visited him, but he spent many weeks alone in his lodgings. In letters to his wife, he complained about his loneliness on more than one occasion and described himself as an "old hermit". That was not entirely true, however. Matisse always found young women who would act as his models and who were often prepared to do more than that. One of them was Antoinette Arnoud (page 26). He portrayed her on a dozen oil paintings in various costumes and poses; often nude, wearing underwear or—as here—in casual clothes. Her ample black hair is pushing out from under a simple green cap, and she is wearing a long embroidered waistcoat over her unbuttoned, sheer blouse as well as a light petticoat: "Cela suffit" (That's quite enough).

It is astonishing how Matisse succeeds in taming the diversity of forms in this picture. Within a small space he combines the figural (the seated Antoinette), the ornamental (the wallpaper), the concrete (table, chair) and the natural (bouquet of flowers). Matisse bans the danger that this diversity of forms and colours might explode within the picture through the generous use of black. The significance he allots to this colour is even expressed in the picture's title. The table top, the black wallpaper in the background, the model's black hair, the black contours of her body and her black stockings hold the composition together and bring a hint of calm, uniting elements that are actually irreconcilable and transforming the intimate scene into a masterpiece.

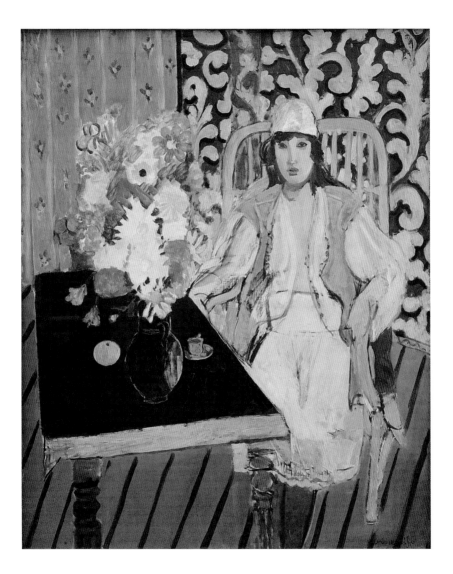

Odalisque with Magnolias, 1923

Oil on canvas
60.5 × 81.1 cm
Private collection

In colonial times, the term "odalisque" was used to describe the usually light-skinned women and chambermaids who lived as slaves in the harem of a sultan or some other high official. They were supervised by the mother of the harem's owner. Harem slaves were usually highly educated, often skilled in the art of calligraphy and were familiar with astronomy, poetry and music.

During the nineteenth century, the odalisque found her way into European art. The best-known representations of the subject were those by the Classical painter Jean-Auguste-Dominique Ingres (1780–1867). The subject remained fashionable until the Roaring Twenties, providing a way to supply the male art public with erotica without sparking a conflict with the Church or the state. The scenes shown did not take place in the "Christian Occident", but in heathen lands, far, far away. The pictures were viewed with complacent disapproval.

However, artists too leaped at the subject, since it provided them with an opportunity to show female nudes or semi-nudes in poses which for European women at least would have been considered unbeseeming.

The *Odalisque with Magnolias* is one of Matisse's finest examples of works of this genre. His model Henriette Darricarrère (page 29) makes a convincing odalisque; she appears to be dreaming of something very beautiful and is quietly smiling like a sleeping child. It would be gaudy kitsch if it were not painted so exquisitely!

The contours and colours, the interplay of light and shade and the fine modulations on the face and body of the sleeping lady are of supreme artistic refinement. The same applies to the paravent behind the reclining woman. The alternation between light and dark shades of blue makes the wall appear to dissolve and creates a space full of mystery.

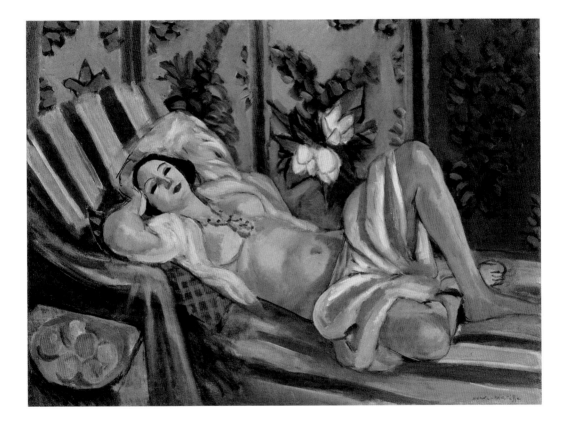

Large Odalisque with Striped Trousers, 1925

Lithograph
54.5 × 44 cm
Bibliothèque nationale de France, Paris

Matisse was not only an exceptionally gifted painter, but also a brilliant illustrator and graphic artist who mastered all the various aspects of that art. We know of charcoal and chalk drawings ranging from powerful to coarse; he was equally at home using pen and pencil and had an excellent command of graphic printing techniques. Nonetheless, he availed himself of the services of the Paris firm Mourlot Frères when it came to printing editions. The brothers Fernand, Georges and Maurice had taken over the printing works after their father's death and were regarded as the best "artist's printers" in Paris. They produced books and posters, but also printed original graphic editions of lithographs. Their customers included Georges Braque, Marc Chagall, Giovanni Giacometti, Henri Matisse, Joan Miró and Pablo Picasso, among others.

As in the oil painting (pages 70/1), Matisse treats his model, Henriette, very circumspectly in the lithograph. He is clearly endeavouring to produce a realistic portrait rather than subjecting it to any kind of experiment or playful forms. It is evident that he wants to capture all aspects of her beautiful appearance. "Matisse took pleasure in Henriette's natural dignity, her upright gait, which indicated a fit body, and the graceful way she held her head. [...] She worked as a dancer, played the violin and possessed a natural talent for painting—talents which Matisse encouraged in her as he did in his own children."

Gilles Néret writes: "In his oeuvre Matisse allows us to recognise a type of woman who is very much more than a personal ideal. In fact, she represents that of an entire era, comparable with the waitresses in Renoir's works or Degas' dancers. This ideal is in a way a magnificent reflection of the age."

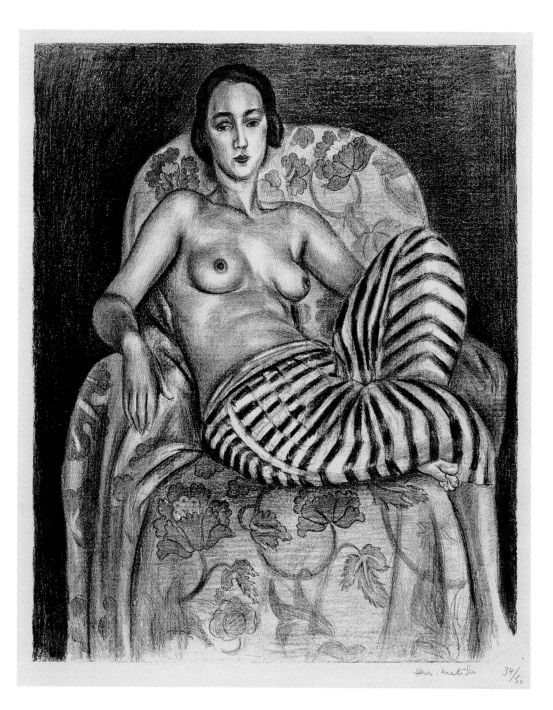

Henri Matisse 34/50

Back (Nu de dos) IV, 1930

Bronze
191 × 116 × 13 cm
Musée Matisse, Nice

Three more versions—all in the same format and displaying an abstraction that
became progressively more pronounced—would follow *Back I* during the years
1913–1930. In *Back IV* the nude seen from the rear is reduced to a symbolic stele.
The body consists simply of two half-columns, in the middle of which, following the
line of the spine, a long plait is dangling down.

It is said that Matisse advised his students to construct a sculpture in exactly the
same way as a house. "Everything must be constructed—built up of parts that form
a whole: a tree like a human body, and a human body like a cathedral." Whether the
saying has been handed down accurately or was just fictitious: it describes precisely
the French artist's sculptural thought processes. He is not concerned with recording
the interplay of the muscles, the function of the limbs, the structure of the skin in the
way he had so admired in the works of Rodin. *Back IV* is no longer the image of a
body; it shows its construction.

In 1991 the art historian Ernst-Gerhard Güse wrote of the *Back* sculptures: "Matisse
does not abandon reality in his works. But in his search for permanency and truth,
he has arrived at the brink of complete abstraction in the *Back* reliefs. In another
context Matisse spoke of the inner light of the artist and the poet, which re-shapes
things in order to create from them a new world which can be perceived with the
senses and classified; a living world bearing in itself the infallible emblem of the
divine which is the reflection of the divine itself."

This world, created by artists and removed from reality, appears in Matisse's oeuvre
not only in his drawings and paintings, but also—as this work shows—in his sculptures.

The Dance, 1932/3

Oil on canvas
339,7 × 441,3 cm (left); 355,9 × 503,2 cm (middle); 338,8 × 439,4 cm (right)
The Barnes Foundation, Philadelphia

In addition to the "odalisques," music and dance were among Matisse's favourite motifs. As early as 1909/10 he had painted two pictures on these subjects for the Russian collector Sergei Ivanovich Shchukin which are on view today in the State Hermitage Museum in Saint Petersburg (pages 50/1 and 52/3). Twenty years later he took up the subject again, this time as a commission for an American collector. Albert C. Barnes came from a petit-bourgeois family, studied medicine and worked at one stage as a doctor. Then he studied pharmacy—in Heidelberg and elsewhere—and finally founded his own firm, the A. C. Barnes Company. He became a highly successful businessman, was also active in the social field and began to collect modern art. Initially he exhibited it in his factory before having a building erected for his excellent collection of twentieth-century French art in Merion near Philadelphia in 1924. He had purchased fifty-nine works by Matisse alone.

In 1931, Matisse took advantage of the opportunity presented by his return journey to Europe from Tahiti to visit the collector in Merion. Barnes commissioned him to decorate the arched wall spaces over the doors of the large room in his private museum with three pictures on the subject of "Dance". Each picture could command a space of almost twenty square metres.

Back in Nice, Matisse rented a former film studio and started work on the largest wall picture that he would ever paint. First of all he created drawings, colour sketches and several large oil pictures on canvas. They show the same scene in very different colour schemes. Among these sketches, the oil painting on canvas *The Dance of Paris (Dance 1), Ochre-coloured Harmony* captivates the viewer with its harmonious colour scheme and the balanced composition between the opposing poles of rest and movement. The first version of the painting in its original size was created after this sketch but had to be abandoned because Matisse had been working from incorrect measurements. The final composition presents considerably more abstract and geometric forms than the previous sketches. During his preparations Matisse had used a new working technique in which he combined cut-out pieces of coloured paper with one other.

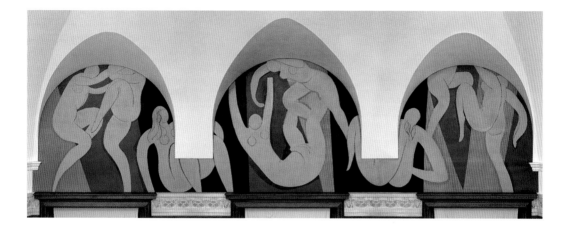

Faun Bewitching a Sleeping Nymph, 1935

Charcoal on paper
154 × 167 cm
Musée National d'Art Moderne, Centre Pompidou, Paris

In Greek mythology, nymphs are female nature spirits that can appear in a variety of forms. As naiads, they protect the springs and streams; as nereids, they swim in the sea, and as dryads they inhabit the forest. They are all young and beautiful, and they are symbols of sexuality and fertility.

Faunus, known as Pan in Greek, is the protector of nature and the forest, and in this function he is responsible for the fertility of man and beast. Since the Greek and Roman pantheon was a remarkably human place, encounters between Faunus and the beautiful nymphs must have inevitably occurred.

The *Barberini Faun*—the most famous representation of the god—can be admired today in the Glyptothek in Munich. It is immediately comprehensible that the sleeping youth with his fine facial features and flawless body, created in about 220 BC, aroused great interest on the part of the nymphs.

The subject also inspired musicians and artists. Stéphane Mallarmé completed his poem *L'après-midi d'un faune* in 1879, further inspiring Claude Debussy to his composition *Prélude à l'après-midi d'un faune*. Vaslav Nijinsky, the choreographer and dancer of the famous avant-garde ballet ensemble Ballets Russes, combined the poem and dance to create a magnificent ballet performance, which in turn Henri Matisse used as his source of inspiration for his drawing. The elegant interplay of lines, incised by hand in the copper plate, lends the image density and elegance.

Hans Hildebrandt, Professor of Art History at the Technical University in Stuttgart and until 1933 one of the forerunners of Modernism in Germany before being prohibited from working by the National Socialists, wrote on the subject of Matisse's graphic works: "His line always strikes the essential. That is why Matisse can limit himself to mere hints which offer the viewer the pleasurable compulsion to join in the act of creation by completing what is missing."

Reclining Nude, 1935

Pen and Indian ink on paper
45 × 56 cm
The State Hermitage Museum, Saint Petersburg

"They are drawings consisting of a single line which only ends when the drawing is complete." That was how Louis Aragon, the Surrealist poet, described Matisse's works in a novel. Indeed, the pen-and-ink drawings from the 1930s focus entirely on the line; there is no hatching, there are no shadows and no reflections. Matisse reduces the representation to the absolute essentials, but he does so with the confidence of a sleepwalker: each stroke, each flourish, each arabesque is convincing and necessary for the elegant overall effect of the sheet.

Matisse even achieves a spatial effect via the sophisticated picture structure in these sheets, although he never deviates at any point from his purely linear form of representation. The viewer's eye recognises the scene in the mirror and unconsciously completes the missing elements, namely the shadows and spatiality.

When the sheets were to be shown in London, they were greeted initially with resistance according to Hilary Spurling: "The problem was the unusual combination of absolute allegiance to the truth and the aesthetic rigour which these pictures present. It was impossible to misconstrue the sensuousness of their lines, which spiritedly dance around the curves and hollows of the body and pause appreciatively on the outlines of the beckoning fingers, the budding nipples, the vivacious tangle of pubic hair." The model for these wonderful drawings was Matisse's assistant Lydia Delectorskaya. Matisse said that her face and body were as familiar to him as the alphabet. But the relationship between the artist, by now over 70 years of age, and the young woman was not a sexual one. It took place on a different plane and was characterised by friendship and their working partnership. Matisse's biographer Hilary Spurling judged: "If Matisse had a love affair with Lydia, its consummation took place on the canvas!"

Lady in Blue, 1937

Oil on canvas
93 × 74 cm
Private collection

It is hard to imagine that Matisse should paint a picture like the *Lady in Blue* during
the 1930s, when he was creating his lively drawings that revelled in the physical
forms of his models. No three-dimensionality, no seductive body, no enticing gesture!
This lady is a flat as a board, and the entire picture consists of flat areas of colour.
The figure has been painted without any form of modulation and displays only the
most subtle hint of ornamentation. The fact that the picture resembles a cut-out is
heightened by the symmetrical structure of both the areas of colour and the objects
in the picture. The curving arms of the bourgeois-looking sofa create additional
severity and confinement, as does the palette, reduced to a small number of locally
placed colours: blue, red, black and yellow.
A letter to his artist friend Pierre Bonnard reveals that Matisse was well aware of
the danger that his attempt to reduce the painting to smooth areas of colour and
ornamental forms meant. "I have the drawing that I need, because it expresses the
peculiarity of my feelings. But my painting is inhibited [...]. It does not match my
spontaneity, which sometimes leads me to throw away work achieved over a long
period of time within just a minute."
In any case, this picture is far removed from everything that Matisse had drawn and
painted during the previous months. Perhaps it was just simply a "counter-reaction"
to the elegance and sensuousness of his scenes of dancing and music.
He painted several more pictures in this vein, albeit in less pronounced form. With
the painting *The Music* from 1939 (page 35) this attempt at form had been exhausted.
He moved on to an impressive late phase of his expressive painting which is charac-
terised by soft black contours and strong colours.

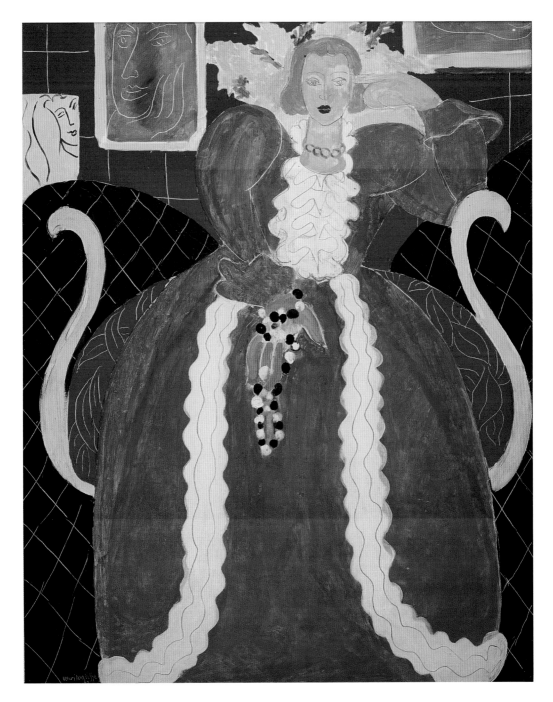

Two Dancers, 1937

Cut-out / Collage (Papier découpé)
80.2 × 64.7 cm
Musée National d'Art Moderne, Centre Pompidou, Paris

This work served as a sketch for the curtain of the ballet *Red and Black*, a per-
formance by the famous Ballets Russes in Monte Carlo. The choreography was by
Léonide Massine, the head of the ensemble. Matisse designed the costumes, the
stage set and the curtain; he also designed the programme. Matisse's biographer
Hilary Spurling writes: "Massine and Matisse worked together to develop a scenario
which aimed to represent the continuing struggle between White and Black,
between the intellect and the physical side of humanity." In this sketch Matisse
worked mainly with blue, white and yellow paper. It shows a dancing figure in
black with outstretched arms radiating strength and dynamism. The arms are raised
powerfully, while a figure in white and yellow hovers above. The dynamics recall
ballet dances. However, it was the farandole in particular, a traditional folk dance
from the Provence, which inspired Matisse to many of his dance compositions.
The protagonists form a human chain or hold cloths in their hands which link them
together, giving the individual dancers more freedom of movement. In swaying
steps—almost hopping, in fact—the procession moves forwards in time with the
music. If no band is playing, the procession is led by a flute player, whose moves
result in various shapes, for example circles, figures of eight, ovals and serpentine
lines. This imaginative dance has found its way into high art elsewhere. Georges
Bizet composed the Farandole from *L'Arlésienne-Suite*, which is often played in
purely concert performances as well as being performed as a ballet. There is also a
Farandole in Charles Gounod's opera *Mireille*. In 1884 the German artist Hans Thoma
saw it not as a roguish round dance, but painted the *Farandole* as a series of staid
hops in a circle.

85

Still Life with Magnolia, 1941

Oil on canvas
74 × 101 cm
Musée National d'Art Moderne, Centre Pompidou, Paris

This picture does not tell a story; it overwhelms us with its suggestive colour scheme.
Five objects are distributed symmetrically across the smooth, glowing red of the
background. The centre space is dominated by the vase with a white magnolia,
with a copper vat behind it encircling the flower like an aureole. The arrangement is
accompanied by four objects (clockwise): a blue flowerpot, a yellow shell, a purple
water jug and—severely truncated by the edge of the picture—a green vase. The
viewer searches in vain for an impression of depth and shadows.
Françoise Gilot and Pablo Picasso saw the picture in 1945 at a major exhibition of
contemporary art in the Musée National d'Art Moderne in Paris. Picasso found the
work too decorative and criticised the fact that although the objects touched each
other, their overlapping was not shown spatially. Gilot saw the picture very differently:
"I found the surprising juxtaposition of the individual parts interesting because it
did not destroy the unity of the whole. [...] The subject was treated without any
kind of rhetoric, the objects were neither related to each other in any sort of logical
connection, nor did they show any other form of ingenious relation to each other—
they were simply there. [...] The picture positively glowed. It was full of happiness
and yet seemed to evade the viewer. [...] The whole thing reminded me of the figures
on the painting *Dance* [pages 50/1] from 1910 [sic], executing their leaps for joy in a
closely structured round dance. Two hands come very close to each other, like the
forefingers of God and Adam on Michelangelo's painting *The Creation of Adam* in the
Sixtine Chapel, but they do not touch and hence generate a thrilling tension."

Study (Léda et le Cygne), c. 1942–46

Black Conté-crayon on paper
27 × 21 cm
Private collection

The study was produced for a large triptych which is definitely one of the most curious pictures that Matisse ever painted. It was commissioned by Hortensia and Marcello Anchorena, a couple from Argentina. They were regarded as rich eccentrics, but they were not art collectors. Nonetheless, they had successful artists paint all the doors in their flat in the Avenue Foch in Buenos Aires. Françoise Gilot recalled: "The *Leda* by Matisse adorned the door of Hortensia's bathroom, a real showpiece. Diego Giacometti designed the bronze door handles, Jean Cocteau decorated the grand piano and Picasso created an abstract silhouette of my figure."
Matisse chose the subject "Leda and the Swan", the icon of which is the missing painting of the same name by Michelangelo. On this work Zeus, the head of all the Greek gods, approaches Leda in the form of a swan. The powerfully erotic picture, created in 1529/30, shows openly how the couple kisses and consummates its love. Michelangelo's painting became the most famous artistic rendering of the subject in Europe. The original has not survived; the copy in the National Gallery in London originated from the circle of Rosso Fiorentino.
In Matisse's picture we can sense little of the erotic tension and artistic strength of the former painting. The swan which approaches in flight attempts to kiss the seated Leda, but she adopts a defensive pose. In the final work she even turns her head away. The simplification of form reaches its climax both in this sketch and in the large triptych; the entire picture becomes a sort of pictogram.

Polynesia—The Sea, 1946

Cut-out / Collage (Papier découpé)
200 × 314 cm
Musée National d'Art Moderne, Centre Pompidou, Paris

During the spring of 1940, Matisse was diagnosed with bowel cancer, and a year later he had to undergo a major operation. He spent almost three months in a hospital in Lyon, which weakened him tremendously, and he suffered from two pulmonary embolisms. After being discharged from hospital he began to work again but remained physically weak.

In the summer of 1946, the artist, now aged 76, returned to Paris from Vence, where he had spent the spring. He was in poor health and Lydia and a nurse looked after him around the clock. He slept badly, suffered from strong, painful cramps, and spent restless nights racked by nightmares. "Memories which he had absorbed like a sponge fifteen [sic] years previously, resurfaced in the twilight zone between waking and sleeping", writes Hilary Spurling.

He began to work on two large-format wall decorations: *Polynesia—The Sky* and *Polynesia—The Sea*. He asked Lydia to buy him some blue paper, but she could only find wrapping paper in two shades of blue. He marked out the background for *Polynesia—The Sea* like a chess board and had Lydia glue the blue sheets onto strong packing paper. He cut the figures out of ordinary white drawing paper and with the help of his assistant arranged them across the entire picture surface. *Polynesia—The Sea* is impressive simply because of its size—it is more than three metres wide. Against the blue-in-blue background, all kinds of birds and sea creatures cut their capers: the sky and the sea fuse to form a single living space. Five considerably larger forms—a fish, two birds and two water plants—stabilise the composition. Around them a wide variety of creatures with fantastic forms swarm. In addition to Matisse's beloved seaweed shapes we can see little fish and octopuses, birds and imaginary creatures—a wonderland drawn with a pair of scissors.

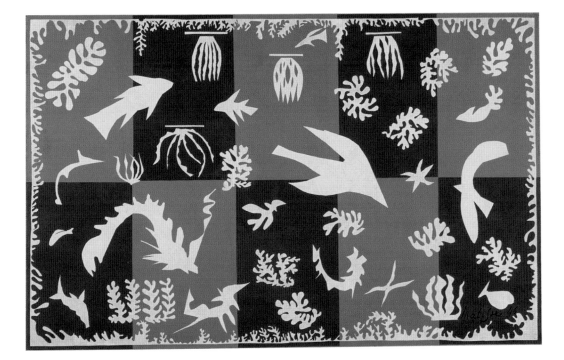

Icarus, 1947
Artist's book Jazz, plate VIII

Pochoir (stencil print)
33 × 42 cm
Tériade, Paris

"Drawing with scissors" became a passion for Matisse. The artist alone was res-
ponsible for cutting out the shapes, but his assistants helped him to arrange and
glue the individual forms onto the paper background. His cut-outs, the *papiers
découpés*, were created as single items.

On 2 May 1897, a child by the name of Stratis Eleftheriadis was born on the island
of Lesbos. At the age of 18—in the midst of the turmoil of the First World War—the
young man from a wealthy family left home and moved to Paris to study law and
become a lawyer. Before long, however, he was drawn towards art. He shortened
his family name and called himself henceforth E. Tériade. He became the chief
editor of the famous art magazine *Cahiers d'Art* and from 1933 published elaborate
books on contemporary art together with the Swiss publisher Albert Skira, including
works on Marc Chagall, Le Corbusier, Alberto Giacometti, Henri Matisse, Joan Miró
and Pablo Picasso and others. From 1937 he was the publisher of *Verve*, a quarterly
highbrow art magazine.

In 1943, when Tériade saw some of the *papiers découpés* on the subjects of *Jazz*
and *Circus* in Matisse's studio, he immediately wanted to make them into an
elaborate artist's book. Henri Matisse was very receptive to his ideas and together
they embarked on the project. But how could they reproduce the cut-outs and still
preserve the unique character of the sheets?

There is no reliable source from which we can discover which of the two had the
idea of using the pochoir technique for the reproduction of the coloured cut-outs.
As early as 1925, the graphic artist Jean Saudé had produced guidelines for this type
of stencil printing.

The pages of illustrations are accompanied by hand-written pages with "notes" by
the artist—printed using the silk-screen method –, which are not only interesting
to read, but which also result in fascinating double pages in conjunction with the
pictures. Matisse wrote: "The unusually large size of the writing seems to me to be
very important, so that a decorative interaction occurs in relation to the coloured
plates."

un moment
di libes.
Ne devrait-on
pas faire ac.
complir un
grand voyage
en avion aux
jeunes gens
ayant terminé
leurs études.

54

The Codomas, 1947
Artist's book Jazz, plate XI

Pochoir (stencil print)
42.2 × 65.1 cm
Tériade, Paris

The circus with its variety of acts developed into a theme for art even during the nineteenth century. The Cirque Fernando in Paris was especially popular with painters. It was here that Edgar Degas found the subject for his *Miss La La at the Cirque Fernando*, and Toulouse-Lautrec, Auguste Renoir and many others also turned their attention to the genre. Pablo Picasso, Matisse's friend and perpetual rival, liked to attend the circus and painted harlequins and jugglers during his Rose Period in particular.

Matisse's album *Jazz* comprises twenty plates, eight of which are dedicated to the subject of the circus. The large-format stencil prints were created during the years 1944/5, and the artist wrote the accompanying texts in 1946 after completing the series.

The trapeze artists Les Codomas were two brothers whose daredevil swinging and leaping delighted the audience. They worked on the so-called "Flying Trapeze". That meant that one of the performers would let go of his trapeze and execute various figures, pirouettes and leaps, before finally being caught by his partner.

Although the degree of abstraction in Matisse's depiction is very high, the events are powerfully portrayed. We can recognise the two swings between which the artistes fly like serpents as they sway to and fro. The protagonists are surrounded by plant-like structures whose restless forms further heighten the dynamics of the action. Black squares on a yellow background have an almost static effect as they indicate the circus ring and calm down the composition. The sheet captivates the viewer with its balance between rhythm and dynamism.

The Lagoon, 1947
Artist's book Jazz, plate XVIII

Pochoir (stencil print)
42 × 65.5 cm
Tériade, Paris

On this cut-out Matisse wrote:

"Lagoons,
are you
one of the seven wonders
in the paradise of artists?"

Seventeen years had passed since Henri Matisse set off on his long journey to Polynesia, and he was already 77 years of age. Nonetheless, his memories of the South Seas were still very vivid and had become even more pronounced over the years, so that now the urge to turn them into art was overwhelming.

Matisse had come back from his extended trip apparently without results; he had not painted a single picture and immediately after his return, he was still unable to do so. The effect that the diversity of forms and colours had had on him was simply too overwhelming. He wrote: "Most painters need direct contact with the objects in order to feel that they exist, and they can only record them under the exact physical conditions of their existence. They need a light from the outside in order to be able to see clearly themselves."

This "light from the outside" had been too strong: the harsh yellow and green, purple and deep blue had beguiled him, but he needed first to find a creative concept before he could dare to express his memories in art. Painting was not the right medium, but he succeeded with his cut-outs.

Portrait of Lydia Delectorskaya, 1947

Oil on canvas
64.5 × 49.5 cm
The State Hermitage Museum, Saint Petersburg

Matisse was not only an artist with heart and soul; he also always remained a theorist. He was interested in design principles and art history; he studied the Old Masters and observed precisely what his fellow artists, especially Picasso, were doing. He was also interested in German Expressionism but remained reserved with regard to the artists' associations *Die Brücke* and *Der Blaue Reiter*.

This portrait of his assistant and muse Lydia Delectorskaya certainly shows a delight in experimentation. The picture is divided into a small number of coloured areas. The yellow and blue of the face—light and shadow—are mixed to form the green of the hair. The drawing does not follow this unusual use of colour. Here there is no appropriate enhancement of the expression. The representation is reduced to a handful of lines, but we can sense that Matisse nonetheless wanted to make his muse look "pretty". Expressive exaggeration—if we think of the *Brücke* artists or Jawlensky's portraits alone—looks different to this.

It was Matisse's permanent curiosity when exploring new artistic territory and his daring to try formal experiments that led him to this picture. It was one of the many detours that Matisse took, but one which always led him back to his true female image. Françoise Gilot recognised this fact even at the time. She wrote: "The beauty of a model prompted in Matisse a creative process which made him aware of his own lyrical longings. [...] He loved the presence of women. Although he had to spend most of his time at home because of his unstable state of health, he was nonetheless anything but a cloistered hermit. The gaiety of his pretty young models opened a window on the world for him whilst he was working. Listening to their chatter, he would capture the expression of a fleeting moment, finding inspiration in their beauty for the shadowless freedom of his outline drawings or exalting them in masterly simplification on one of his glorious paintings."

99

Red Interior with Still Life, 1947

Oil on canvas
116 × 89 cm
Kunstsammlung Nordrhein-Westfalen, Düsseldorf

In the spring of 1945, Matisse received a surprise visit in Vence from the retired country doctor Dr. Léon Vassaux, who had made the journey to once more see Henri, his best friend from his youth. They knew each other from their childhood in Bohain and had remained close friends during their time as students in Paris. Not even the fact that the two young men had both fallen simultaneously in love with Caroline Joblaud, who had then decided in favour of Matisse, could destroy their friendship.

Léon Vassaux had brought something special with him as a present for his host: Matisse's first sculpture. It was a plaster medallion with Caroline's profile. Hilary Spurling wrote: "Camille [as Caroline liked to call herself, and as she was known to her friends] was now also in her seventies. She was married to a retired teacher and lived in Brittany. In the meantime, the long years that had passed had gilded her memory of her time as the fêted focal point of the Parisian Bohème."

In a gesture of wistful reminiscence, Matisse hung her plaster portrait on the wall of his studio. And so, two years later, the former lover and idolised woman found her way into the *Red Interior*; her medallion is hanging on the left beside the balcony door.

The *Red Interior with Still Life* belongs to a series of almost thirty pictures created in 1947/8 which show interiors exclusively. Matisse limits himself to a small number of colours (red, blue, yellow and green), which he applies two-dimensionally. The black lines lend the picture a graphic structure, thus pointing forward to the later works on paper. They were to be Matisse's last paintings; after 1948, he would only create cut-outs. The most famous ones were the twenty templates for the stencil prints in the album *Jazz* (1947, pages 92–97) and the series *Blue Nudes* (1952, pages 108/9).

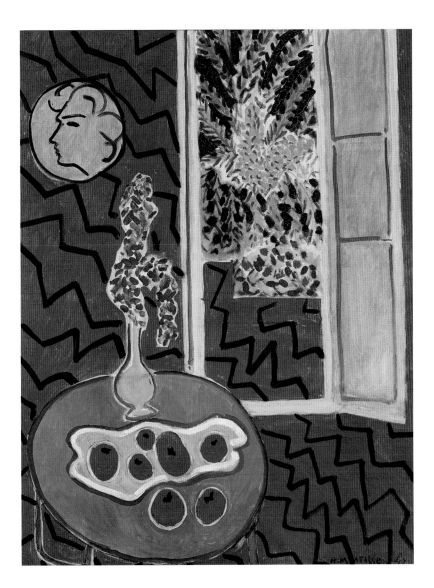

The Egyptian Curtain, 1948

Oil on canvas
116 × 89 cm
The Phillips Collection, Washington

With *The Egyptian Curtain* Matisse perfected what he had heralded in *Red Interior with Still Life*. There are only a small number of local colours which he has applied almost without modulation. Here, however, black becomes the most important element in the picture, because simply by serving as a contrast it permits the colours to glow with an intensity never achieved before!

This painting could not have been created without the wealth of cut-out forms. In his last painting cycle, Matisse succeeded in transferring the artistic language and expressiveness of his cut-outs back into his painting. So it was not only due to the effort involved in the act of painting—which his ill body was by then scarcely able to achieve—, that Matisse stopped painting after completing this picture, in order to simply "draw with scissors" during the last years of his life.

The artist frequently explained that in his painting he had never followed a fashion or a "trend", nor had he worked according to a theory, but rather his artistic activities had always been the result of following an inner compulsion. The pictures ruled him and determined his development, forcing him to continue along the path he had embarked on, without his knowing where the journey would take him. Now he had reached a point where his "old" artistic activities—painting—and the "new" formal language of the *papiers découpés* met and fused with each other, equally entitled to stand side by side and on one level with each other. And for the Old Master that was the moment when he could put down his paintbrush forever.

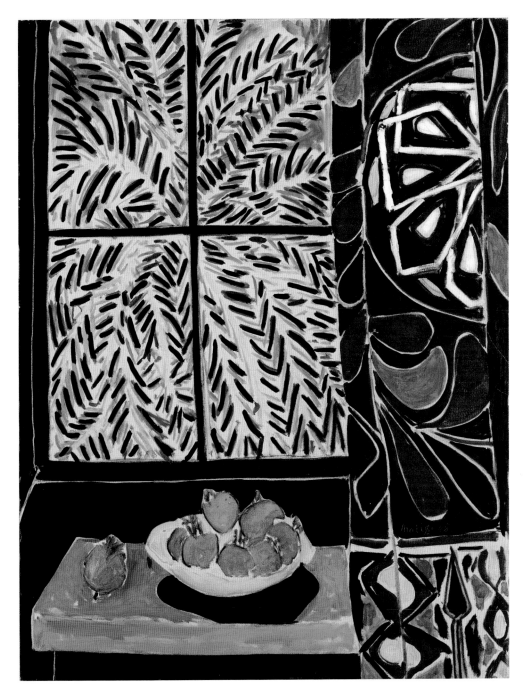

Pale Blue Window (Vitrail bleu pâle), 1948

Cut-out / Collage (Papier découpé)
509.8 × 252.3 cm
Musée National d'Art Moderne, Centre Pompidou, Paris

Matisse was not a churchgoer. He was not pious in the usual sense but lived according to his own standards. He did not see himself as an atheist, however. Hatred in every form, especially when it was disguised as religion, was anathema to him. For Matisse, God and Love were almost synonyms. In his album *Jazz* he quotes from *De Imitatione Christi* by the mystic Thomas à Kempis:

"Nothing is sweeter than love, nothing more courageous, nothing higher, nothing wider, nothing more pleasant, nothing fuller nor better in heaven and earth; because love is born of God, and can rest in naught but God, above all created things. The lover flieth, runneth, and rejoiceth; he is free and is not bound."

During the course of 1942/3 Matisse was ill and was cared for by the nurse Bourgeois in Nice, who had previously worked in the Hospital of the Order of Dominican Nuns (Ordo Praedicatorum) in Vence. After the end of the war she returned there as a nun called Sister Jacques-Marie and worked in the Hôpital Foyer Lacordaire. There she had the idea to create a chapel in one of the outhouses of the clinic and turned to Matisse for advice. Impressed by the nun's enthusiasm, he promised to take on the artistic design of the little church Chapelle du Rosaire together with all the associated costs. He created the stained glass windows and decorated the chapel with wall paintings. He developed the sketches for the windows as cut-outs; one of them shows a tree of life. The colours and forms which Matisse had so admired in Polynesia in 1930 take effect once again here in a monumental format. Inside the chapel, the brilliant colours of the windows stand in exciting contrast to the sparse black brush drawings on a white background with which Matisse adorned the walls. He even created the designs for the priest's vestments: "I want people to be purified and freed from their burdens when they enter my chapel. Designing it really woke me up."

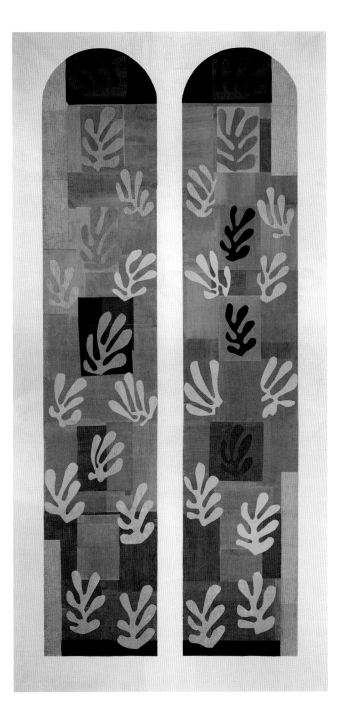

Beasts of the Sea, 1950

Cut-out / Collage (Papier découpé)
295.5 × 154 cm
National Gallery of Art, Washington

Amongst the "late results" of Matisse's journey to Oceania was this monumental cut-out, which measures almost three metres in height. In order to give the giant format enough stability, he first glued a canvas with monochrome, light-coloured paper. On it, a wide variety of forms and colours are arranged across two large, column-like areas. The papers Matisse used were first dyed in different colours by the maestro's assistants using gouache paints. The artist alone was responsible for cutting out the shapes. His helpers could then take over again with regard to the arrangement of the individual shapes on the background, according to the artist's strict instructions. In this way, despite his poor health, Matisse found a method of continuing to create pictures that lived up to his expectations until his death in 1954.

The picture displays a high degree of abstraction. The viewer's imagination is called upon even in the case of the black forms, which vaguely recall fish or crabs, in order to recognise specific sea creatures. However, if we do not approach the individual forms with "scientific" interest ("What sort of a creature could that be?"), but rather allow the picture in its entirety to have an effect on us, we shall not doubt for a minute that here the artist really has portrayed an underwater world teeming with life.

Many of Matisse's late works reveal this surprising effect. Although the artist has used only non-representational forms and colours which do not exist in real life—especially not under water—a convincingly realistic picture nonetheless forms in the mind's eye of the viewer. Yes, that is an underwater world, and it is precisely the one that we must preserve and protect: beautiful and diverse, colourful and full of life!

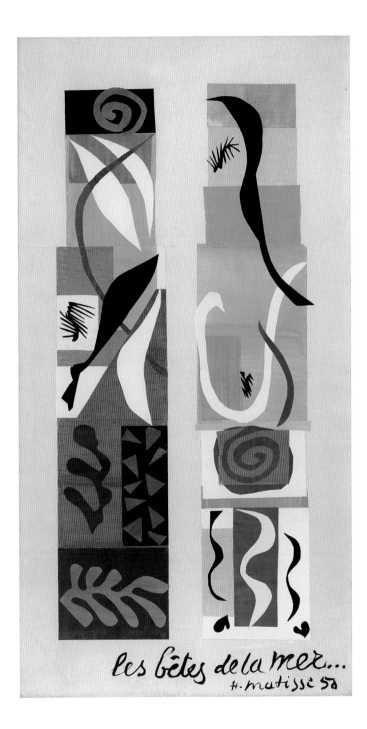

les bêtes de la mer...
H. matisse 50

Blue Nude II, 1952

Cut-out / Collage (Papier découpé)
105 × 74 cm
Musée National d'Art Moderne, Centre Pompidou, Paris

According to Hilary Spurling, "Matisse knew that he did not have much time left, and that each work might turn out to be his last. With remarkable control, he cut each of his motifs in just a few minutes from the stiff paper painted with gouache and waited impatiently until it had finally been glued into place. The speed at which he worked in the four successive *Blue Nudes*, had Paule Martin [his assistant] reeling with exhaustion."

In the series of *Blue Nudes* from 1952, Matisse dispensed entirely with accompanying motifs, decorative ornamental forms or hints of landscapes. The women's bodies are composed of areas of uniform colour, whereby Matisse has used the same cut-out technique as for his large-scale works for the Chapelle du Rosaire in Vence from 1948 (pages 104/5) and *Beasts of the Sea* from 1950 (pages 106/7). Nonetheless, the impression created here is a very different one.

Through the limitation to a single colour, a wonderfully matt and yet luminous blue, Matisse has pursued the reduction and simplification of forms still further. The papers he has used are coloured uniformly and completely. However, with only a single colour the artist can create neither light nor shadow in order to lend the body sculptural depth.

In spite of this limitation to one single shade, Matisse achieves the feat of transforming this single tone into an orchestral work, at the same time simulating a spatial representation that does not exist in reality. He paradoxically creates three-dimensionality by way of a purely two-dimensional design.

Françoise Gilot possessed a keen sense of this magnificent artistic achievement: "Even at an early stage, from the time of his *Blue Nude* from 1906, Matisse had dreamed of painting human bodies in the colours of the sky. When we visited him in 1946 he was already working on a pale blue nude, and Picasso had remarked at that time that a transposition of colour like that demanded a treatment of form that was detached from all imitation. Now, in 1952, Matisse had reached his goal and had fulfilled his dream."

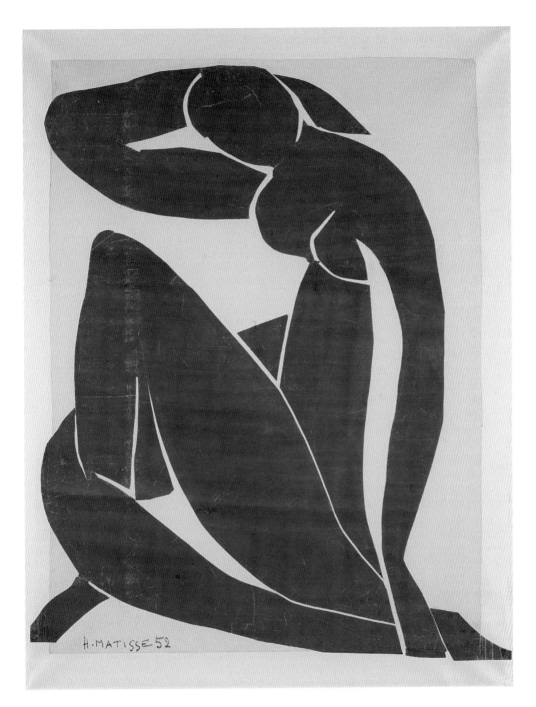

FURTHER READING

Berggruen, Oliver and Max Hollein, *Henri Matisse—Drawing with Scissors*, Munich, 2014

Essers, Volkmar, *Matisse*, Cologne, 2012

Gianfreda, Sandra et al., *Matisse—Metamorphosis*, Zürich, 2019

Gilot, Francoise, *Matisse and Picasso, A Friendship in Art*, New York, 1990

Güse, Ernst-Gerhard (ed.), *Henri Matisse: Drawings and Sculpture*, Munich, 1991

Güse, Gerhard-Ernst and Katrin Wiethege, *Henri Matisse—Jazz*, Munich, 2001

Kraemer, Felix (ed.), *Matisse—Bonnard: Long Live Painting!*, Munich, 2017

Néret, Gilles, *Henry Matisse*, Cologne, 2006

Néret, Gilles, *Henri Matisse. Cut-Outs.* Cologne, 1996

Spurling, Hilary, *The Unknown Matisse. 1869–1908*, London, 2000

Spurling, Hilary, *Matisse the Master: A Life of Henri Matisse: The Conquest of Colour, 1909–1954*, New York, 2007

Wolf, Norbert, *Henri Matisse—Erotic Sketchbook*, Munich, 2007

CREDITS